W9-CJE-615

AN INTRODUCTION TO
ACRYLICS

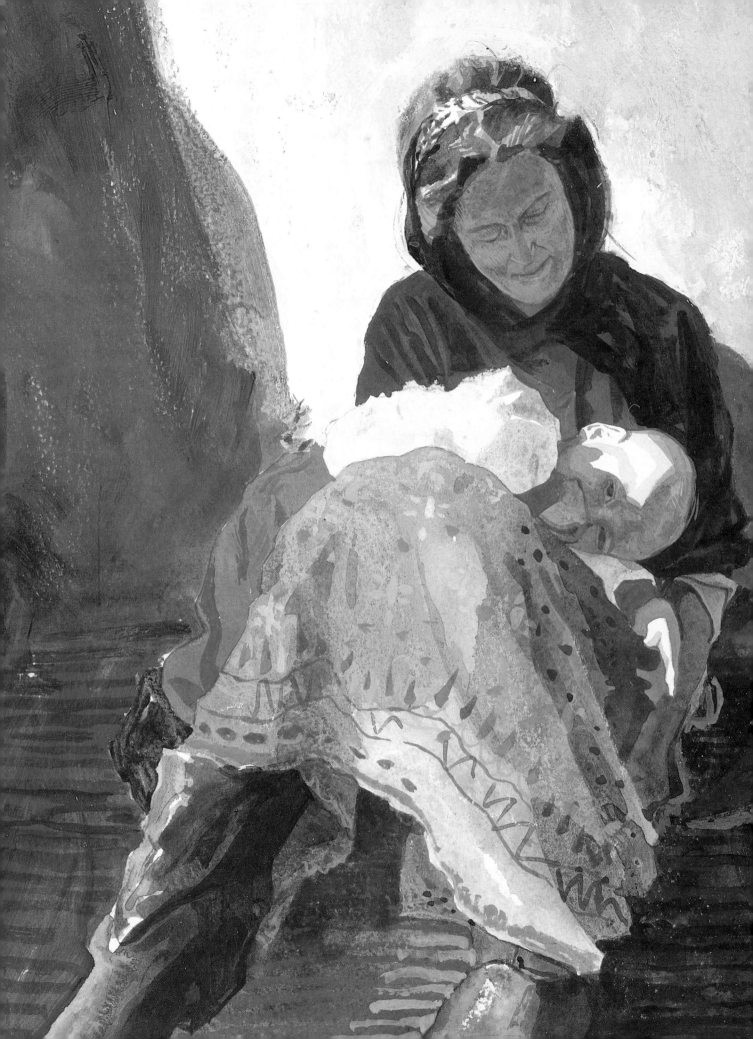

The DK Art School

AN INTRODUCTION TO
ACRYLICS

RAY SMITH

DORLING KINDERSLEY
LONDON • NEW YORK • STUTTGART
IN ASSOCIATION WITH THE ROYAL ACADEMY OF ARTS

A DORLING KINDERSLEY BOOK

Project editors Ann Kay, Lynne Nazareth
Art editor Brian Rust
Designers Stefan Morris, Dawn Terrey
Editorial assistant Margaret Chang
DTP designer Zirrinia Austin
Series editor Emma Foa
Managing editor Sean Moore
Managing art editor Toni Kay
U.S. editor Laaren Brown
Production controller Helen Creeke
Photography Clive Streeter, Phil Gatward

First American Edition. 1993
2 4 6 8 10 9 7 5 3 1

Published in the United States
by Dorling Kindersley, Inc.,
232 Madison Avenue, New York, NY 10016

Library of Congress Cataloging-in-Publication Data

Smith, Ray, 1949–
 An introduction to acrylics/Ray Smith. -- 1st American ed.
 p. cm. -- (DK art school)
 Includes index.
 ISBN 1–56458–373–2
 1. Acrylic painting--Technique. I. Title. II. Series.
ND1535.S65 1993 93-19078
 751.4'26--dc20 CIP

Color reproduction by Colourscan in Singapore
Printed and bound by Graphicom in Italy

CONTENTS

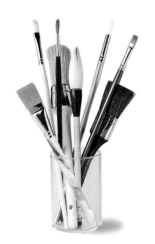

ACRYLICS

A CRYLIC PAINT is a relative newcomer to the world of painting media. While oils have been in use for centuries, acrylics have only been available in recent decades. But they are an important addition to the repertoire of painting materials because their flexibility makes them suitable for a wide range of techniques – as the images on these pages show. Depending on how much acrylics are diluted with water, they can be used either opaquely or in a transparent watercolor style.

Thin washes of acrylic allow a textured painting surface to show through and add interest to the image

Opaque acrylic is ideal for even, flat coverage, or for much thicker effects, with highly visible brushwork. Interesting paintings can be built up easily and quickly with opaque acrylic. Because the paint takes so little time to dry, you can cover your painting surface rapidly, and any overpainting – perhaps to correct mistakes – will obscure layers underneath. If opaque and transparent methods are combined within a painting, you can incorporate the kinds of scumbles, glazes, and rich, thick impasto normally associated with oils, while acrylics are also uniquely suited to a number of much less conventional approaches.

Opaque acrylic paint creates vivid and saturated colors

Using transparent washes

Thinned acrylic washes can be applied wet-in-wet or used in many of the other methods that are common to watercolor painting. Acrylics, however, have an important advantage over watercolors. Once acrylics are dry (and they dry very quickly), they are insoluble, which means that they can be overpainted readily without disturbing the dried paint layer

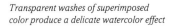

Transparent washes of superimposed color produce a delicate watercolor effect

Mixing transparent washes and opaque techniques in one painting will give a creative depth and texture to your work

underneath. Try exploiting this fully by superimposing a large number of washes to create resonant color effects. Watercolor paints, however, are also associated with various ways of lifting color off the painting surface. These methods are inappropriate to the use of thinned acrylic once it has dried. Acrylics dry so rapidly that if you want to modify the color while it is wet, you must get used to working quickly.

Advantages of acrylics

One of the main advantages of acrylics is that they are largely water-based. Apart from making it easy to thin the paint, this also means that there are none of the toxicity problems linked with the kinds of solvents – such as white spirit or distilled turpentine – used with oil paints. Another plus for acrylics is that the polymer emulsions binding the pigments form very stable films when the paint dries. Acrylic film is free from the kinds of chemical changes that can take place with the more traditional painting media.

The consistency of thick acrylic lends itself well to thick, energetic impasto work

Preserving color

The only slight disadvantage with the dried acrylic film is that it is relatively soft, especially at room temperature. This can mean that acrylics attract dirt, which may become integrated into the paint film, changing the appearance of the colors so that they lose their brightness. However, this is usually a problem only when you are making your own paint and add very little pigment to an acrylic emulsion – although it can also occur if you use an acrylic medium with a small amount of pigment. You should have few problems with most of the ready-made acrylic paints that are currently available from art supply stores (*see* pp.10–11).

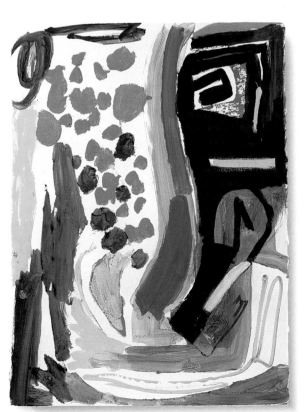

Acrylics are well suited to a highly experimental approach – such as this lively combination of free painting and printing techniques

7

A BRIEF HISTORY

THE WIDE AND varied use of acrylics by artists in the latter part of the twentieth century shows the huge potential of the medium very clearly. From the early days of discovery and experimentation in the U.S.A. to its far more widespread use today, acrylic has become a universally accepted painting medium. Its versatility can be seen in the large and expressive abstracts by pioneers such as Morris Louis *(1912–1962)*; in the images of 1960s Pop Art and the early figurative work of David Hockney *(b. 1937)*; and in the recent, more psychological, tableaux of Paula Rego *(b. 1935)*.

ACRYLIC RESINS – originally formulated in Germany in the early 1900s – were developed in the U.S.A. during the late 1920s by the company Röhm and Haas. The discovery of a way of dissolving resins in organic solvents led to the development of an early oil-compatible form of acrylic paint.

A new medium

By the late 1940s, these early acrylics were commercially available in the U.S.A., where artists such as Helen Frankenthaler *(b. 1928)* and Morris Louis began to work with them. In the latter half of the 1950s, the water-based emulsions that we know today emerged. American artist Frank Stella *(b. 1936)* started using acrylics to explore the relationship between the canvas and marks made upon it. He moved from monochromatic work to richly colored creations.

The medium was taken up in Britain in the 1960s, notably by David Hockney, Mark Lancaster *(b. 1938)*, Richard Smith *(b. 1931)*, Bridget Riley *(b. 1931)*, and Leonard Rosoman *(b. 1912; see p.17)*.

Acrylics and Pop Art

In the 1960s, Roy Lichtenstein *(b. 1923)* and Andy Warhol *(1928–1987)* pioneered the American Pop Art movement, which related fine art to popular culture. Acrylic lent itself to the hard-edged, flat images that expressed modern life so effectively.

Morris Louis, *No. 182,* 1961 *82 x 33 in (208 x 84 cm)*
From 1954 until his death in 1962, Louis developed a distinctive acrylics style. Influenced by the drip paintings of Jackson Pollock (1912–1956) and by Frankenthaler's staining methods, Louis thinned acrylic with solvents and poured it onto unprimed cotton. The paint ran down the canvas, staining it with thin veils of color.

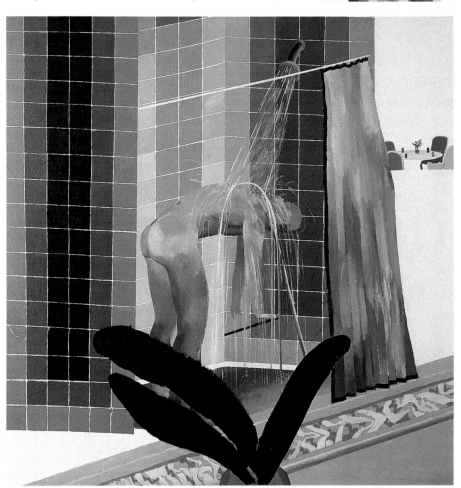

David Hockney, *Man in Shower in Beverley Hills,* 1964 *66 x 66 in (167 x 167 cm)*
Hockney worked with acrylics intensively for around a decade from the early 1960s, when he moved to California. His works from that time contrast thin, flat areas of opaque color with painterly brushwork. Here, bright colors and geometric tiles provide an almost diagrammatic setting for a modern interpretation of the nude.

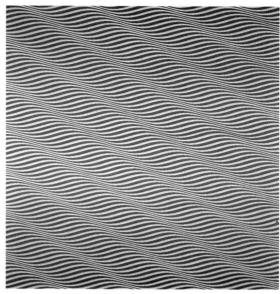

Andy Warhol, *Do-it-Yourself Landscape*,
1962 *70 x 54 in (178 x 137 cm)*
This bright, hard-edged effect was a trademark of Pop
Artists such as Andy Warhol, and is particularly suited to
acrylics. Employing the painting-by-numbers approach used
in children's painting sets, Warhol asks questions about the
decisions that artists make when creating their paintings.

Bridget Riley, *Cataracts III*, 1967
88 x 87 in (224 x 221 cm)
Riley made her name in the 1960s with her "Op Art" works,
which explore surface illusionism. Working against the flat
format of the canvas, she creates flowing, vibrating images.
The blue wave moving across this work splits to reveal a
growing band of red – the central powerhouse of the work.

Photo-realist painting

During the latter half of the 1960s
and into the 1970s Americans
Richard Estes *(b. 1936)* and Chuck
Close *(b. 1940; see p.60)*, and British
artist Malcolm Morley *(b. 1931)* made
acrylic works based closely
on photographs. Close's
huge portraits and Estes'
street scenes may bear
an uncanny resemblance
to photographs, but the
spectator becomes more
actively engaged with a
crafted, painted image.

The late 1970s and
early 1980s saw a return
to a more expressive
and personal style. K.H.
Hödicke *(b. 1938)* made
direct works confronting
the issues of recent

German history. In the U.S.A.,
Jim Nutt *(b. 1938)* was exploring a
uniquely personal vision, and British
painter Alan Charlton *(b. 1948)* found
that acrylic gave his monochromatic
works a flawless, matte surface.

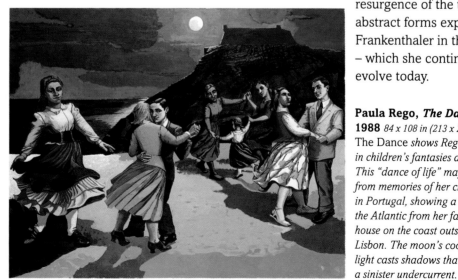

Modern movements

The 1990s have seen a move toward
more figurative paintings dealing with
issues of personal, public, and artistic
identity – such as the recent works
by Paula Rego. There has also been a
resurgence of the type of
abstract forms explored by
Frankenthaler in the 1950s
– which she continues to
evolve today.

Paula Rego, *The Dance*,
1988 *84 x 108 in (213 x 274 cm)*
The Dance *shows Rego's interest*
in children's fantasies and fears.
This "dance of life" may spring
from memories of her childhood
in Portugal, showing a view over
the Atlantic from her family's
house on the coast outside
Lisbon. The moon's cool blue
light casts shadows that create
a sinister undercurrent.

ACRYLIC PAINTS

Paints on the market
Acrylics are available in tubes, jars, and tubs. They are also sold in bottles, for use with airbrushes.

ACRYLIC PAINTS REPRESENT A SIGNIFICANT advance in paint technology in this century, and are constantly improving as the medium is developed. They are water-soluble, which means that there are none of the health hazards associated with the volatile solvents used with oil paints, yet they can be used in many of the same techniques. When diluted with a lot of water, acrylics produce an effect strikingly like that of watercolor paints, yet they also have their own unique characteristics. Acrylic paints vary in consistency, depending on the manufacturer – some are flowing and liquid; others are more viscous.

WHILE OIL PAINT IS pigment bound in a drying oil, acrylic paint consists of pigment bound in an acrylic polymer or copolymer emulsion. Acrylic polymers are synthetic resins made from chemicals called monomers. The monomers are put through a polymerization process, which creates a synthetic resin with strong elastic properties. This resin is made into an emulsion consisting of particles of polymer suspended in water. The emulsion used in acrylics is normally a copolymer.

This incorporates mixed polymers specially chosen for their ability to form a good, fairly hard film. Acrylic paints dry on the painting surface – by evaporation of the water in the emulsion – to form an inert film that is water-resistant.

You can make a perfectly good oil paint by simply grinding a pigment with a drying oil, but it is more

difficult to make a really reliable acrylic paint by mixing pigment with acrylic emulsion (both of which are commercially available). Ready-made paints tend to be preferable because

Thick acrylic – an effective glue

Using acrylic paint opaquely
You can use all acrylics opaquely, provided they are applied thickly – either straight out of the container or with very little water added – or mixed with white. This is important when painting on a toned ground.

Opaque paint

Note how acrylic dries to a darker color

Extruded strip of dried paint

Plastic properties
When it dries, acrylic paint takes on the tough and malleable quality of plastic. It is therefore unique among painting media because it can be extruded, knotted, or even sculpted in three dimensions.

Acrylic paint as glue
Acrylic is actually a fairly fast-drying type of glue. Because of this, it works well in collage techniques with light materials such as cardboard, provided the paint is used thickly.

they contain a specially formulated balance of additives that preserve the paint, give it body, stability, and a good consistency, and prevent it from foaming or freezing in transit.

PVA paints

In some schools, teachers make paints similar to acrylics by adding a PVA medium to a mixture of water and powdered color. PVA is another type of resin – polyvinyl acetate. Commercially available PVA paints are similar to acrylic paints, but they

tend to be inconsistent in quality, sometimes producing a brittle paint film. However, there are several very high-quality makes.

Acrylic mediums and retarders

Acrylic mediums are substances that can be added to paint to adjust its consistency for special effects such as glazing or impasto, or to make it

glossier or more matte. Retarder can be added to slow down the paint's drying time and keep it workable – useful for techniques like blending.

Paint mixed with texture paste

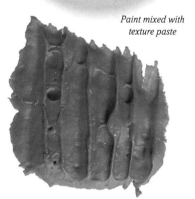

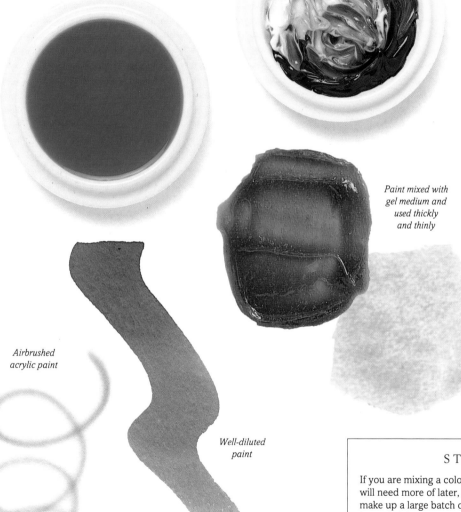

Paint mixed with gel medium and used thickly and thinly

Airbrushed acrylic paint

Well-diluted paint

Above: Paint with texture paste

You can create highly textured effects with thick, impasted paint, by mixing special pastes into your acrylics. One very coarse paste even contains pumice.

Left: Paint with gel medium

Gel medium offers you a choice of effects. A lot of gel with a little paint added can create a translucent impasto. Scraped or painted thinly across a surface, gel mixed with paint produces a transparent glaze.

Watered-down acrylic paint

Well-diluted acrylic can be used as an equivalent to watercolor. It has the advantage of drying insolubly, so that additional layers of color do not dissolve lower layers. Diluted acrylic also works well in an airbrush.

STORING PAINT

If you are mixing a color that you know you will need more of later, it makes sense to make up a large batch of it. Keep the mix in an airtight, screw-top jar, as acrylics dry quickly when exposed to air.

11

SELECTING YOUR COLORS

BECAUSE ACRYLICS are relatively new, paint manufacturers have been able to use the best new pigments, along with the reliable traditional ones. Lightfastness – a pigment's ability to withstand fading – is important. Good, lightfast colors include Quinacridone violets and reds; Phthalo blues and greens; Cadmium reds and yellows (*see* p.71) and Azo Yellow; the earth colors – Ochres and Siennas; and Titanium

White. Metallic colors are also available. To understand how colors work together to create different effects, you should be aware of basic color theory. The three primary paint colors are red, yellow, and blue, and these can be set out, with related colors in between, in the form of a color wheel.

COMPLEMENTARY COLORS are those colors of maximum contrast opposite each other on the wheel. The complementary of each of the three primaries is the color you get by mixing the other two. So, the complementary of red is green (a mix of yellow and blue); the complementary of yellow is violet (red and blue); while that of blue is orange (yellow and red).

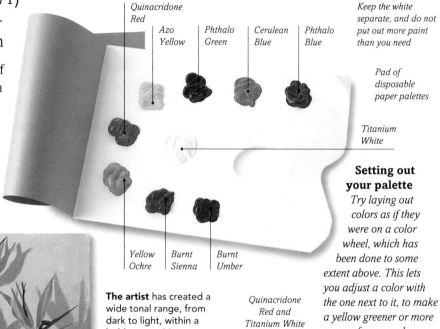

Quinacridone Red

Azo Yellow

Phthalo Green

Cerulean Blue

Phthalo Blue

Keep the white separate, and do not put out more paint than you need

Pad of disposable paper palettes

Titanium White

Yellow Ochre

Burnt Sienna

Burnt Umber

Setting out your palette
Try laying out colors as if they were on a color wheel, which has been done to some extent above. This lets you adjust a color with the one next to it, to make a yellow greener or more orange for example.

Titanium White

Cadmium Yellow

Quinacridone Red

Phthalo Blue

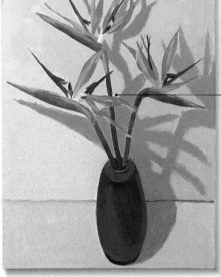

The artist has created a wide tonal range, from dark to light, within a bold composition.

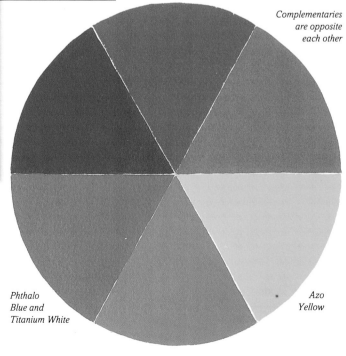

Quinacridone Red and Titanium White

Complementaries are opposite each other

Phthalo Blue and Titanium White

Azo Yellow

Limiting your palette
Experiment with limiting your palette. This will give you the invaluable experience of mixing color and tone using just a few basic colors. The vase of flowers shown above has been painted using just the three primaries and white. The work is high in key, with opaque paint applied in bright, pure color mixes.

The color wheel
This opaquely painted color wheel shows the three primaries and the three secondaries – violet, orange, and green – obtained by mixing two primaries. The specific red and blue paints used here are naturally transparent, and so a little white was added to make them opaque. Using these fairly pure paint colors, you could mix almost any hue.

Placing your colors

Every color affects the appearance of the color next to it in a painting. If you look hard at an area of strong color, and then look away, you see the complementary of the color you have been looking at. This can affect the color of whatever you look at next. So, an area of bright yellow may appear greenish after looking hard at orange-red, because you are carrying the blue after-image of the orange-red. This optical effect is known as "color irradiation," and is well worth considering when you are painting.

Bold red and green

Use complementary colors to interact with each other, producing bright contrasts and an overall color balance in your work. In this painting, the exotic red flower stands out very effectively against the lush green of the foliage.

Subtle effects

This shows how washing one complementary over another subdues the colors, as combining complementaries produces gray or black. Green washes on the red petals create rich shadows, while red touches have deepened the color of the leaves.

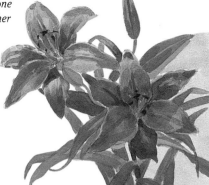

Adjacent colors

This afterimage effect means that if we place two complementaries right next to each other, one will reinforce the intensity of the other. Aim for balance – if a painting is predominantly blue, only a few touches of orange are needed to intensify our experience of the blue.

The term "adjacent colors" also refers to colors that are next to each other on the wheel. Use these adjacents to produce the subtle harmonies shown below.

Transparent color wheel

This wheel also shows the primaries and complementaries, but painted in thin acrylic washes. The mixes that tend to the adjacent color on each side of a wheel segment are in the outer circle. Using thin acrylic allows you to create hues not just by physically mixing colors, but by washing one color over a dried wash of another.

Red and violet

Here, a cool red is deepened in places by a further wash of the same color. The adjacent color, violet, is used for deeper shadows by washing it over the red.

Blue and violet

Delicate washes of adjacent blues and violets harmonize this image. Good wash effects rely on the luminosity of the support. Use high-quality white paper or white priming.

Orange, yellow, and green

There is a gentle quality to this painting, which arises from the use of orange-yellow to shade the petals, combined with the yellow blending into the adjacent green of the stalk.

USING COLORS

APPRECIATING HOW COLOR works the best in a painting – particularly in your own painting – is something that you ultimately learn by trial and error, and by looking at the work of other artists. Ask yourself certain questions about the colors you use. Is the color key appropriate for the atmosphere or mood that you want to evoke? A work can be high-key, with clean, bright primary and secondary colors used at full strength, or it may be low-key, incorporating a more subdued range of neutral tones. Mood is also established by the "temperature" of colors – if a work is mainly orange and red, it will have a different atmosphere than one painted in cool colors such as blue or green.

A GOOD OVERALL COLOR balance is essential. One important aspect of colors used next to each other in a painting is the intensity of those colors. Where you are using a particularly intense or saturated color, you may need only a small touch of it in a much larger

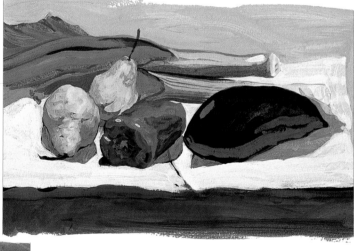

Above: Altering the color balance

The three paintings on this page show how the mood of a work can be altered. This first picture is basically low-key. A soft, natural light source falls from the right onto the objects. These images are created with washes of transparent acrylic paint; later changes have been superimposed with opaque paint. Throughout the painting, the colors are harmonized within a relatively subdued range of tones.

Right: Adding life

The artist has decided that he wants to start brightening the image. Changing to overhead artificial lighting gives a harsher, more even light. He has added livelier reds, such as Cadmium Red, to the pepper, lighter greens to the leeks and pears, and light shadows of Ultramarine Blue mixed with white. The striped cloth has become a white one.

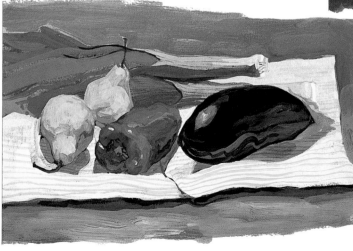

area of another less intense color to achieve a good balance between the two.

We all tend to perceive some kind of balance of colors in whatever subject we choose to paint. The more we paint, the clearer it becomes that we are imitating a sense of order that we perceive in the

Left: The final image

Every tone in the painting has been livened up. Dark tones in the foreground and background of the table have been overpainted with mixes of Yellow Ochre and Cadmium Yellow and Yellow Ochre and Burnt Sienna respectively. The aubergine has been brightened by working light transparent washes into the dark areas. Yellow stripes added to the white cloth lift the whole composition.

world around us. This means that we must learn to adjust the tones and colors that we use so that we can achieve a similar color balance in our paintings.

Making adjustments
The effect of colors on each other runs through the whole course of painting, and applies to tiny paint particles just as much as it does to large areas of color. Making the slightest adjustment to a color in one part of a work can affect the whole composition – appropriate changes must be made elsewhere.

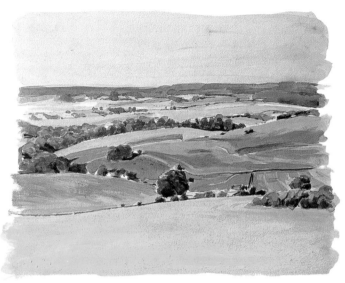

Using colors to show recession
In this landscape painting, a warm, bright yellow has been used on the fields in the foreground. Our eyes move naturally from this vivid foreground back through the cooler shades as the fields gradually recede into the hazy purple-blue used to indicate the distant horizon.

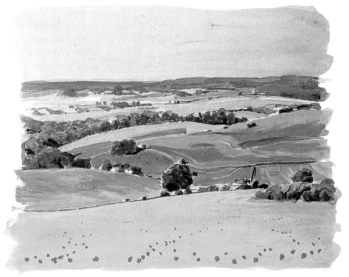

Bringing up the foreground
Bright colors tend to come forward in a painting. Here, touches of strong, bright red – to indicate poppies in the field – have been used to emphasize the foreground. Just a small amount of a bright color such as red can totally alter the perspective emphasis of a painting.

Creating specific effects
The warmth or coolness of a color affects our perception of perspective and distance in a painting. Warm colors appear to advance, and cool colors recede. Fields that are shown yellow-green in the foreground of a painting should be blue-green as they recede. This is because of the influence of aerial perspective – an effect of nature where objects in the distance take on a pale blue hue.

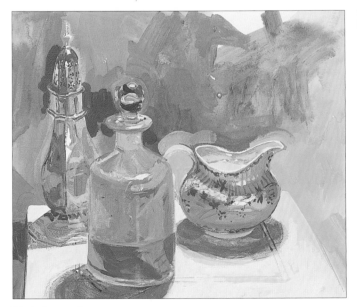

High-key colors
The high-key reds, oranges, and yellows that dominate this work create a light, sunny mood. Shadows are painted in light blue, rather than in black or gray. Sparkling reflections have been created either with opaque white paint, or by leaving areas of the surface of the white paper exposed.

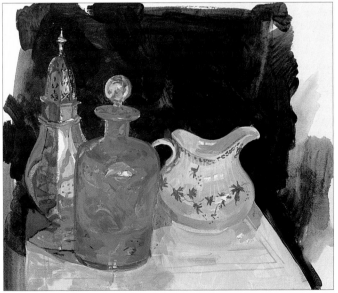

Low-key colors
The same subject assumes a completely different, and very somber, air when painted in a low-key range of colors. Dark blues, greens, purples, and browns – colors that tend to recede – seem to push the objects farther away from us than in the high-key version.

15

GALLERY OF COLOR

COLOR IS THE KEY to establishing the mood or atmosphere of a painting. It can be high-key, in bright, saturated colors, or low-key, in subdued tones. It can rely on the harmony and balance that is set up by using colors that are adjacent to each other on the color wheel, such as reds, oranges, or yellows, or it can rely on contrasts set up between complementary colors, such as violet and yellow, for its balance. While surrounding a color with a very dark tone makes it glow, surrounding it with white makes it appear deeper in tone. Above all, it is the choice and use of color that sets the mood or tone of a painting.

John Hoyland, ARA,
Tiger Mirror, **1990**
60 x 60 in (152 x 152 cm)
A color can be made to glow and sing by being enclosed in a dark gray or black. This has the effect of isolating the color and allowing it to be perceived in all its purity. In the recent past, artists such as Léger and Rouault have exploited this technique, and long before that, such an effect could be seen in the great medieval stained glass windows. John Hoyland's snaking, dripping brushstroke in two-tone orange-red and crimson pink has a glowing lusciousness against the dark ground. The color of Tiger Mirror*'s ground has the effect of pushing the brushstroke forward and adding to the immediacy of the work.*

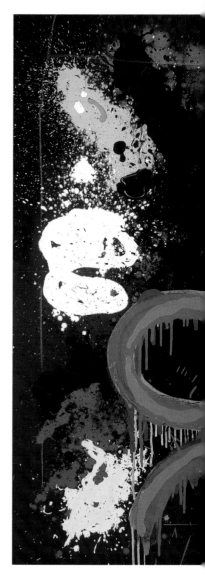

Gregory Gordon,
Portrait of the Artist's Mother-in-Law
24 x 18 in (61 x 46 cm)
Gordon's unconventional use of color lends an exuberant strength to this lively portrait. The multicolored speckled surface seems to make the image vibrate and shift slightly as we continue to look at it, bringing the subject alive. It is as though colored lights were playing in front of our eyes.

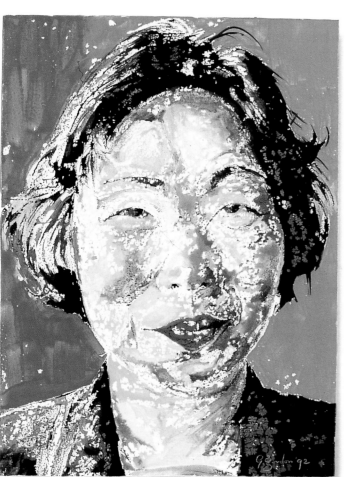

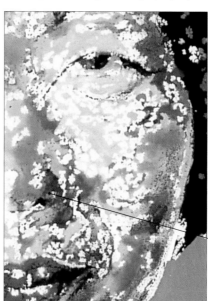

Examination of any one area of the face shows how many different colors – mainly primaries and secondaries – have been used to convey the flesh tones. Although our eyes tend to merge these different colors optically, this process is helped by the fact that the artist has worked with diluted paint, allowing colors to blend and fuse.

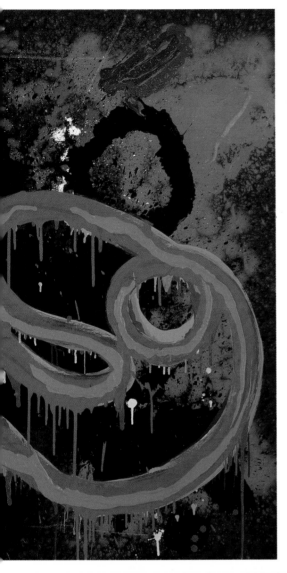

In this detail, the dark ground encloses the blue-violet, making it vibrate beneath the brightness of the thickly splashed-on yellow paint.

The vivid yellow leaps out from its black surround. It does so more particularly because there is a blue behind it. To achieve this effect, the artist has to ensure that the paint is thick and opaque enough to obliterate the dark ground completely.

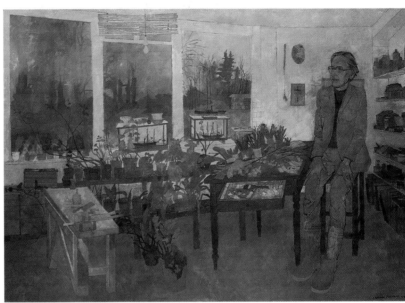

Above: **Leonard Rosoman, RA, The Painter Richard Eurich in His Studio, 1988** *48 x 66 in (122 x 168 cm)*

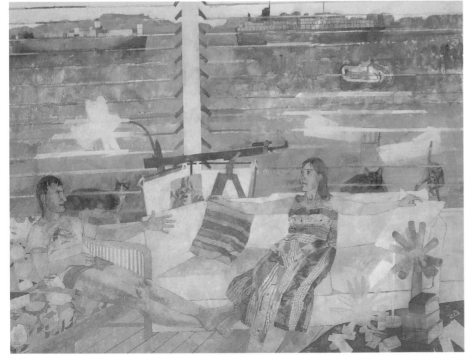

Left: **Leonard Rosoman, RA, Brian and Kathleen, Elk River, Maryland, 1990** *53 x 71 in (135 x 180 cm) These two portraits by Leonard Rosoman are stylistically similar but very different in their use of color, showing how the choice of key can radically affect our perception of a picture. The portrait of the painter Richard Eurich is predominantly low-key, and here Rosoman has deliberately subdued his palette to evoke the quiet atmosphere of the room and the gentle character of the sitter. The use of color reinforces the feeling of calm reflection that permeates the mood of the work. In contrast, in the double portrait, the artist has chosen a deliberately high-key approach to color. The sun shines into this large, airy room and the characters are relaxed, the bright saturated yellows and greens helping to create a mood of light and celebration.*

BRUSHES

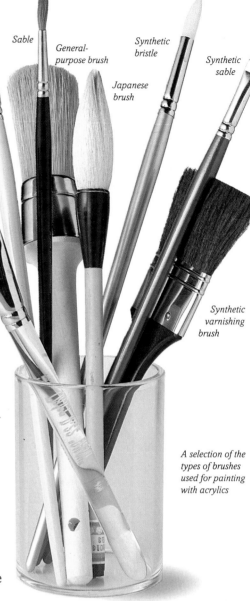

Bristle

Sable

General-
purpose brush

Synthetic
bristle

Synthetic
sable

Japanese
brush

Sable
wash
brush

Synthetic
varnishing
brush

Ferrule

Hairs

Toe (tip)

PAINTBRUSHES ARE MADE either with stiff or soft hairs. The natural hairs that are usually used are bristle for stiff brushes, and sable for softer ones. Both bristle and soft paintbrushes are also available made from synthetic fibers, and synthetic brushes are very commonly used for painting in acrylics.

A selection of the types of brushes used for painting with acrylics

WHEN BUYING YOUR PAINTBRUSHES, you should bear in mind that synthetic brushes are a less expensive option – and they are perfectly adequate for all types of acrylic work. Bristle brushes are generally used for large-scale work and for broad painting techniques. Soft brushes are ideal for painting in thin washes, for watercolor-type techniques, for very small-scale work, and for achieving various other specific effects.

There are two main brush shapes: flat – in which the ferrule has been flattened – and round. Either of these can be made with long or short hairs. Another brush type, called a filbert, has a round head with a flattened ferrule, and so is effectively two brushes in one. It can be used either as a flat brush, for applying broad areas of color, or for more precise techniques, using its thin edge.

Other brushes

You can experiment with other types of brush to achieve a range of effects. For example, an ordinary shaving brush is ideal for working with thinned-down paint.

You may find that you also need a varnishing brush. This thin and flat long-haired

BRUSH CARE

Wash your brush thoroughly at the end of a session, as shown here. Synthetic brushes are especially prone to the build-up of paint where the hairs join the ferrule, leaving the hairs splayed out and the brush ruined *(below)*.

1 *Dip the brush in a jar of cold water to loosen the paint. (Remember that hot water could damage your brush.)*

2 *Use a cloth to wipe off any excess paint. You may need to rinse the brush again in the jar or under the tap.*

3 *Rub the brush over a bar of household soap. Work up a lather in the palm of your hand. Rinse well under the cold tap.*

● *This "Chinese lantern" artists' water pot folds away flat and can be hung up – a useful alternative to the commonly used jelly jar.*

Choosing brushes

Experiment with different brushes to see the variety of effects that can be achieved. For example, the soft Japanese brush shown above is ideal for applying transparent washes.

brush is perfect for laying a smooth, thin coat of varnish over finished works (although varnishing acrylics is a controversial subject; *see* p.68).

It is essential that brushes be kept clean. Acrylics dry rapidly and are water-resistant when dry. Never leave a brush with paint on it for more than a few minutes. Always rinse a brush well after use, and clean it thoroughly at the end of a session. Never use hot water – this can harden acrylic paint on the brush. It may also expand the ferrule, causing the hairs to fall out.

Small round sable
The spring in the pointed toe of a small, round, long-haired sable lets you paint precise strokes with an easy fluency.

No.3 round sable

Larger round soft-hair brush
Larger soft round brushes have a remarkable paint-carrying capacity. Use them to make bold strokes, or to lay thin washes.

No.8 round soft synthetic

Flat soft-hair brush
Noted for their characteristically chunky, rectangular strokes, soft flats are also useful for making long, thin strokes with the edge of the brush.

No.8 flat soft synthetic

Filbert bristle brush
The filbert bristle is one of the most versatile brush shapes, with the flat/round side capable of this kind of rich stroke, and the edge suited to more careful work.

No.5 bristle

Round bristle brush
The round bristle carries a lot of paint and is a good brush to use for thick, impasted brushwork. The toe is capable of more delicate manipulations when the paint is thinned down a little.

No.5 round bristle

Flat bristle brush
Typical brushstrokes produced with a flat bristle are similar to those made with a soft flat, except that paint can be used much more thickly with the stiffer brush.

No.5 flat bristle

Sable wash brush
The flat, "one-stroke" brush is used to lay thin washes over a large area. Have the paper on a slight slope, so that each new stroke picks up paint that gathers on the lower edge of the preceding one.

1in sable wash brush

General-purpose bristle brush
This bristle brush is ideal for painting on a large scale, or for covering sizable areas of the canvas. It can also be used for applying primer. Much larger brushes, such as this, require a great deal more cleaning than smaller ones.

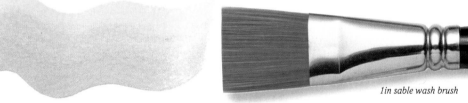

Large, round bristle brush

SPECIAL BRUSHES

There are various special brushes that are used to modify or apply paint in a particular way. Some are specifically made for this purpose, such as the fan blender and stencil brush. However, other brushes can be equally useful, for example the bristle shaving brush shown here, or a "stipple" decorating brush.

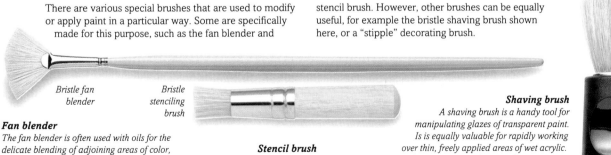

Bristle fan blender

Bristle stenciling brush

Shaving brush
A shaving brush is a handy tool for manipulating glazes of transparent paint. Is is equally valuable for rapidly working over thin, freely applied areas of wet acrylic. This can even out the tone of a transparent color, for example, leaving a uniform stain over a particular area.

Shaving brush

Fan blender
The fan blender is often used with oils for the delicate blending of adjoining areas of color, and large areas can be worked at one time. With faster-drying acrylics, you have to work on smaller areas while the strokes are still wet.

Stencil brush
Stencil brushes have short, stubby bristles and a flat end, so that paint can be dabbed straight down onto the surface through the stencil.

OTHER PAINTING TOOLS

YOU CAN WORK OR MANIPULATE acrylic paint with a wide range of tools other than brushes. Some of these tools, such as painting knives, are traditionally associated with oil painting but work equally well with acrylics; others, such as airbrushes and plastic scrapers, are relatively new to acrylics. Use sponges to lay washes and create texture – just as in watercolor painting.

WHEN WORKING with a painting knife, palette knife, or scraper, you should work either wet-in-wet or wet-over-dry because as soon as a dried skin has begun to form over wet acrylic, any attempt to modify it or add color will usually spoil it. Acrylic paint varies in consistency according to the manufacturer. Some paints have a relatively stiff, buttery consistency straight from the container, which makes them ideal for creating textured effects, while others are much runnier and do not retain their form. The answer in this case is to use specially formulated texture mediums (*see* pp.11,39) mixed with acrylic color to give the paint body, or used to create a textured ground.

Trowel-shaped painting knife

Painting knives
Use a painting knife as if buttering bread. A short blade produces short, intense strokes; a long, springy blade creates great sweeps of color. A blob of color on the end of the blade introduces a pure new tint into wet paint.

Small diamond-shaped painting knife

Glass palette

Melamine palette

Palettes
A large, thick glass slab makes an excellent studio palette. You can put a piece of paper the color of your canvas beneath it to aid color mixing. At the end of a painting session, pour a little warm water onto it and the dried acrylic paint will just float off. For small-scale painting, ceramic dishes or a ceramic palette with wells or slants are ideal. Plastic or melamine palettes are also useful.

Ceramic palette

Atomizer
Use an atomizer to spray a mist of water over your palette from time to time in order to keep your colors wet and workable. Adjust the nozzle to produce a fine mist – avoid drenching the palette.

Palette knives
Palette knives are indispensable for scooping up, mixing, and transferring acrylic color on the palette. Use them to mix in texture mediums, or for mixing in small quantities of ingredients on the palette if you are making your own paint (see pp.10–11). The straight knife has good leverage and a sharp end for scraping up hard color – useful for cleaning the palette.

Straight palette knife

Cranked-shank palette knife

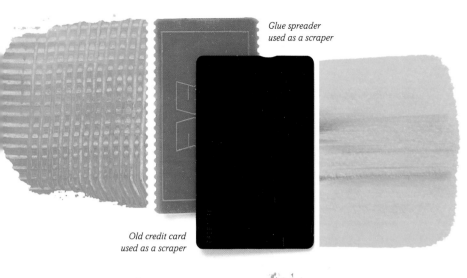

Glue spreader used as a scraper

Old credit card used as a scraper

Sponging and acrylics

Sponges are used to apply washes, create texture, and remove color. Thin the paint to a runny consistency for a wash and apply it in broad sweeps, working from top to bottom. To lift out color, press a clean damp sponge into the damp wash.

Scrapers

Scrapers are versatile tools. Use them to apply acrylic primer or straight acrylic color evenly over large or small areas of canvas, as well as to create striated, combed, and mixed color effects.

Sponge roller

Use light pressure when taking up the paint from the palette to ensure uniformity of texture when the roller is applied to the support. Thicker paint produces a stippled effect, while thin color gives a transparent texture. Superimpose layers of paint and change the direction of the roller for a lively effect.

Sponge

A small piece of natural sponge has excellent paint-carrying capacity for laying washes and producing varied textures. Mix the color well to the required consistency before soaking the clean, damp sponge in it. Synthetic household sponges can also be used to good effect.

USING AN EASEL

- Easels range from solid studio items to light portable ones suitable for working outdoors. Choose one with the facility to secure the painting on it at any angle, so that you can use a wide range of techniques, such as working wet-in-wet with thin paint.

- A mahl stick helps to keep your hand steady while painting – useful while you're standing at an easel, and vital when you need to work carefully into a small area of a large canvas covered in wet paint. Available in wood or metal, the stick is screwed together in sections.

Mahl stick *Easel*

Airbrushes

Use airbrushes and spray guns to add small finishing touches – the glow around a lamp, for example – to a work that has been painted conventionally, or to create large areas of perfectly blended tones. You can also use them to work through stencils or to enhance textured effects. Clean airbrushes and spray guns immediately after use with clean tap water; otherwise, dry acrylic deposits will clog the nozzle and the needle.

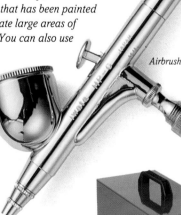

Airbrush

Compressor

21

SUPPORTS – PAPER

NOT paper

Hot-pressed paper

Rough paper

Wove paper

Hand-made paper

Block of paper

THE SURFACE ON WHICH YOU WORK is known as a support; the main types of support suitable for working with acrylics are paper, board, and canvas. If paper is your chosen support, look for acid-free watercolor papers. There are three main types of paper surface: Hot-pressed or HP, which is smooth, Cold-pressed or NOT (meaning not hot-pressed), which has a fine grain surface, and Rough, which is heavily textured. Paper weight varies from lightweight paper at 90lb per ream (185gsm), to 300lb (640gsm), which resembles fine board. Unless you are using a heavyweight paper, stretch watercolor paper first to ensure that it stays firm and flat when the paint is applied.

Paper selection
The surface of the paper affects the appearance of your finished painting. This is just a small selection of the large range available.

Materials

Brushstrokes on smooth paper
When you lay a wash on smooth paper, it can be difficult to achieve an even tone. However, it will show the brushstrokes in a way that other surfaces will not, giving a crisp, delicate effect or emphasizing the fluency of the stroke.

Brushstrokes on rough paper
When washes are used on rough paper, heavier pigments settle into the hollows of the paper, creating grainy textures. If you use thicker paint and more rapid brushstrokes, the paint will miss the hollows of the paper, creating a half-tone effect.

Natural sponge

Gum tape

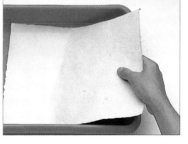

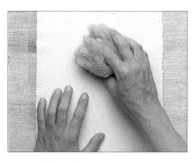

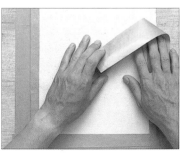

1 ▲ To stretch paper, wet it with cold water, either by submerging it in a water bath, or by sponging the front and back with water until the fibers are fully saturated.

2 ▲ Place the wet paper onto a piece of wood an inch or two wider all around than your paper. Smooth it down with a sponge to remove excess water.

3 ▲ Cut four strips of heavy-duty gum tape, wet them and use them to stick the paper down firmly. Let the paper dry thoroughly to a hard, flat surface.

WORKING STRAIGHT onto white paper is effective when you apply thin washes that allow the luminosity of the white surface to show through. Create highlights by leaving areas of paper exposed. To tone your paper, apply an even, overall wash. Mix up a little more paint than you will need for this initial wash – you cannot afford to run out half-way through. With toned paper, use translucent darks and opaque lights to bring out the forms of your subject.

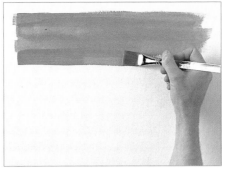

1 ▲ Apply a uniform wash which the white paper still reflects through, using well-diluted paint. Have the board at a slight angle and use a large, flat wash brush.

2 ▲ Fill the brush with color and apply it in smooth, slightly overlapping strokes from left to right. When you have finished, quickly brush out any unevenness.

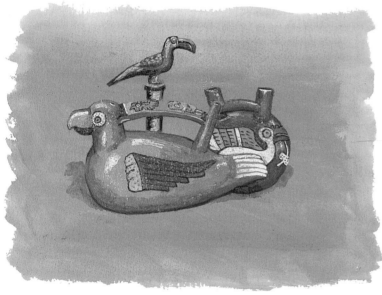

South American antiquities
A mid-toned ground makes a good starting point for a work. Two of the objects are modeled using an orange-red of a deeper tone than the ground and picked out with a touch of Burnt Umber. As the overall wash obscures the white paper, opaque white paint must be used for the white highlights and the painted bird design on the right. The blue shadow here and the green body of the bird behind work well as complementaries (see pp.12–13) to the oranges and reds.

Materials

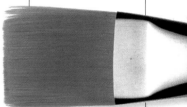

1in synthetic wash brush

Palette of dilute color

In this detail the white of the eye, and the effects of light falling on the face in the eye area, are created using the white of the paper. This draws the attention to the clear and piercing gaze of the subject.

The face is modeled with a series of overlaid brushstrokes, with very little blending. The white ground reflects the colors of each brushstroke, making it possible to read all the stages of the painting.

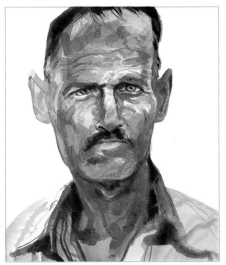

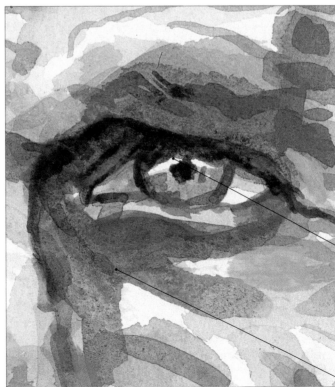

Gaucho
A good quality mold-made acid-free paper can give great clarity to a painting, a clarity which is given force by the intensity of the facial expression. In the areas in shadow the artist has worked wet-in-wet (see pp.42–43) and you can see where the pigment has settled into the grain of the paper to give a textured effect.

BOARDS AND CANVASES

MOST ARTISTS choose to paint on either a flexible material such as canvas or paper, or an inflexible one such as a wooden board. Canvas is a light, transportable, and very responsive surface and although the paint film is more vulnerable on a flexible support, acrylic paint is itself very flexible. Boards are more stable than canvas and almost any kind of rigid board or panel is suitable. Larger boards may need to be glued to a supporting wooden frame to prevent twisting.

A selection of suitable supports

HARDBOARD IS A popular support and deserves its reputation as an economical and hard-wearing material; you can paint on both the smooth side and the textured one. Thicker grades of plywood also make good, solid supports, while blockboard and chipboard are less expensive alternatives.

Medium-density fiberboard, which is used extensively in furniture manufacturing, is equally suitable and even old door panels make excellent supports. Thin cardboard or museum board can also be used, provided it is acid-free. Canvas board, combining the stability of board with the texture of the overlaid canvas, makes a very good support.

Wooden panel

Materials

Sanding block and sandpaper

Large paintbrush

Acrylic gesso primer

Blockboard

Plywood

Chipboard

Medium-density fiberboard

Hardboard – textured side

Hardboard – smooth side

Museum board

Canvas board

1 ▲ To prepare a panel for acrylic painting, cut it to the required size and sand the surface and edges smooth. Clean off all the dust before applying the primer.

2 ▲ Using a household paintbrush, apply a first coat of acrylic gesso primer, diluting it with about ten percent water to make the application easier.

3 ▲ Sand down the panel before applying a second coat of primer. Painting the edges and the back of the panel equalizes the tension in the board, keeping it flat.

Opaque paint on canvas

Canvas is a giving surface, which responds to the brush or painting knife. Where the paint is applied thickly and opaquely (left), *the effect of the brushstroke varies. The texture comes through in the center of the stroke where the paint settles into the hollows of the canvas.*

Transparent washes on canvas

Where the paint is applied in thin, transparent washes (right), *the texture of the canvas comes into its own, integrating paint and support in a unique and expressive manner.*

Materials

Cotton duck (top) *and linen canvas*

Stretchers

Scissors

Staple gun

Hammer

Stretcher keys

Using canvas

Most art supply stores stock prepared, stretched, and primed canvases. In the upper price ranges where properly primed fine quality linen canvas is often used, these tend to be of a reasonable quality. For acrylic painting, you must make sure that the canvas has an acrylic priming. For a sensibly priced, good quality product, buy the stretchers and canvas separately and prepare your own canvases.

1 ▶ Assemble the frame, pushing the corner pieces together by hand. Tap with a rubber hammer (or an ordinary hammer and a block of wood), to avoid denting the frame. Check the right angles using a set square, or make sure that both diagonal measurements are equal.

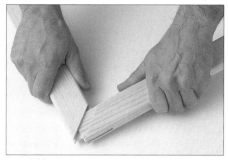

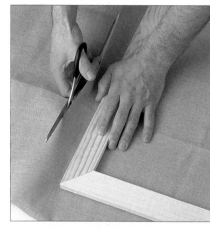

2 ▶ If you are using a cotton canvas, 15oz is preferable; otherwise use linen canvas. Cut the canvas with a generous overlap around the outside edge.

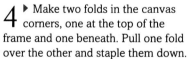

3 ◀ Starting at the center of the first side, staple the canvas to the stretchers. Pull the canvas taut and repeat on the opposite side. Staple the remaining opposite sides in the same way (*see* p.71).

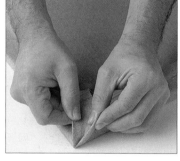

4 ▶ Make two folds in the canvas corners, one at the top of the frame and one beneath. Pull one fold over the other and staple them down.

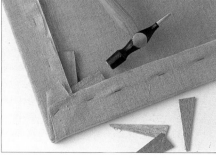

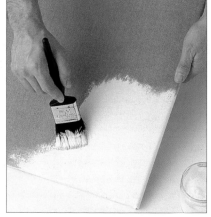

6 ◀ Prime the canvas with two coats of commercial acrylic primer. Thin the first coat, allow it to dry, sand very lightly, and apply a second, undiluted, coat. To make a tinted primer, mix a little acrylic color with water and stir it in well, or apply a thin wash of transparent color over the dry primer.

5 ▲ Tap in the stretcher frame keys to tighten the tension in the canvas. Avoid splitting by ensuring the grain of the wood in the key is not parallel to that of the frame.

GALLERY OF SUPPORTS AND GROUNDS

Y OUR CHOICE OF SUPPORT – whether it is canvas, board, or paper – will have an impact on the way you paint. For example, a rigid board will be more resistant to your brush than a flexible canvas. Whether or not you prime the surface also affects the appearance of your painting; for example, an unprimed surface absorbs more of the paint. If the ground – the surface of the support – is colored or textured, this will also dictate your painting style and the finished effect.

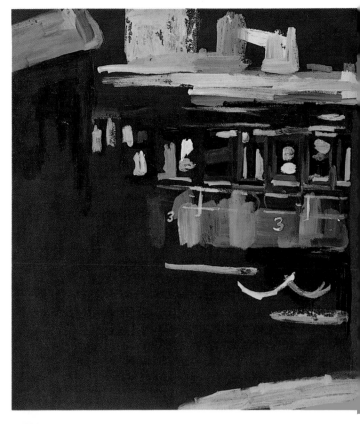

Louise Fox, 3333 *14 x 24 in (35 x 60 cm)*
This demonstrates extremely clearly the use of opaque acrylic on a very dark ground. The paper has been given an overall blue-black tone, so that in order for colors to show up, they need to be either opaque or mixed with white paint. For this technique, concentrate on the highlights and mid-to-light tones, so that the image emerges from the darkness. Here, combining cool blues and greens with touches of orange and warm brown creates the strange, nostalgic atmosphere that artificial light brings to an image (this train is in a museum collection).

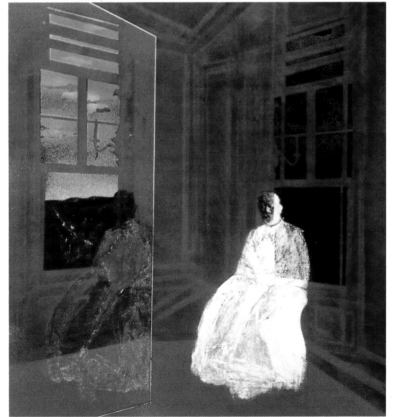

In this detail, the shadows on the window frame were created using a thin dry-brush technique over the red ground.

The white robes – and the light in the sky – were added in with opaque color.

Jacobo Borges, *Yesterday*, 1975 *39 x 39 in (99 x 99 cm)*
The artist has used a red ground, enabling him to paint with great economy. The painting deals with memories and dreams associated with place. In the reflection, the dawn is breaking and the image of the figure is beginning to fade. We start to question which is the "real" image and which the reflection.

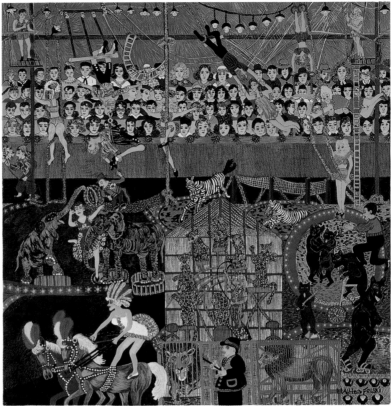

Albina Kosiec Felski, *The Circus*, 1971 *48 x 48 in (122 x 122 cm)*
*The dark ground used here generates the interior, artificial light that
we associate with the circus, picking out all the characters and animals
with a sharp clarity against the darkness behind. The dark stripes on
the zebras are the color of the ground itself, and all the other tones and
details are picked out in opaque mixtures of acrylic paint. There is an
overall surface quality created by the lack of conventional perspective,
which, combined with the rich colors, gives the painting the feel of an
embroidered textile.*

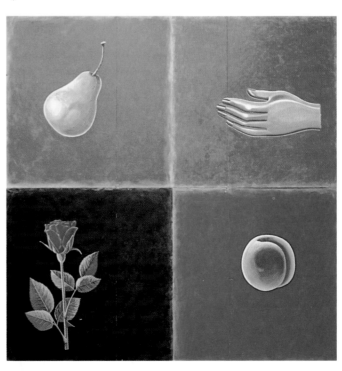

Ronald Davis, *Arc Fan*
114 x 128 in (290 x 325 cm)
Light, airy effects can be achieved
by applying thin acrylic to a white
canvas – particularly if the canvas
is unprimed, when the washes
soak in like a stain on a table-
cloth, becoming part of the fibers.
In this finely drawn perspective
study, we move between the idea
of painting as illusion and as
mark-making on a flat surface.

**Jane Gifford, *Spitalfields
Market; Four Objects***
144 x 144 in (366 x 366 cm)
These four grounds use adjacent
harmonies from dark blue through
blue and magenta to orange-red.
The complementary colors of the
pear and the peach make these
objects seem to float above their
grounds. Using a rigid plywood
support has given an added
smoothness to the paint quality.

WAYS OF WORKING

*Always keep
a sketchbook
on hand*

OVER THE FOLLOWING pages, we explore in some detail the wide range of techniques that you can use when working with acrylic paints. For the sake of clarity, we have looked at particular techniques in isolation. These include many of the ways of using the paint transparently in thin washes, including working wet-in-wet and with resist techniques, overlaying different colors, and painting on textured grounds. We also look at opaque acrylic techniques that range from creating flat, uniform areas of color to thick and vigorous impasto work. However, you will find in practice that both transparent and opaque approaches are often used in the same painting, and that a specific area of a painting may be suited to one form of brushwork, while another area may be worked in an entirely different way.

*Working
with thin
acrylic washes*

*Resist
technique*

The process of painting

Generally speaking, painting should not be a cold, mechanical process in which you select a specific method of working and apply it in a rigidly fixed manner. Try to approach painting with acrylics in an open, organic way, so that, having made a certain decision at one point, you always feel perfectly free to change it quite radically shortly afterward (a good example of this is featured on pp.58–59). This applies just as much to the composition of an image as it does to any particular technique. Use the step-by-step exercises, tip boxes, and Gallery pages in this section to build up your repertoire of acrylic techniques. Then you will be able to call upon them at any time that seems appropriate during the course of working on a painting. This way, you can expand your expressive potential and give yourself more confidence when, for example, you are tackling a new subject or moving on to working on a much larger scale.

Finding your own language

After a while, painters seem to find a way of working that suits their personality and is completely appropriate to their chosen subjects. Each artist's style becomes a form of handwriting that we recognize instantly. There are many examples of this in the Gallery pages throughout this book – examples that range from the liquid economy of John McLean's work (*see* p.47) to the complex configurations created by Bernard Cohen (*see* p.61). If you are new to acrylic painting, you should not expect a uniquely personal style to develop immediately. It is not simply a question of finding a way of working with the paint itself that suits you. Painting is also about discovering an attitude or an approach that allows you to speak with your own voice. As artists, we have to learn to be less self-conscious, to trust our instincts, and to work the way we want to work, not as we imagine we ought to.

Choose the appropriate brushes and painting surface for your style and subject matter

This acrylic equipment is painted in an opaque style

Freedom and experimentation

One good way of getting to know yourself as a painter is to work out ideas as often as possible on scraps of paper or in sketchbooks. As a beginner, it can be intimidating to be faced with a large, untouched expanse of expensive watercolor paper or ready-made, primed canvas. There often tends to be a feeling that, to justify the expense, a perfectly formed painting must appear miraculously on this pristine surface. Inevitably, the result is going to be disappointing. A scrap of paper or a sketchbook, on the other hand, is not at all intimidating – you are quite free to make countless mistakes, or perhaps discover a wonderful new way of working. You will certainly develop far more quickly this way. Give yourself time to experiment with acrylic paints, to use unusual tools and surfaces, and to adopt any methods from other painting disciplines that seem suitable. You may not use any of this material in a finished painting – but you will gain a much fuller understanding of the varied ways in which acrylics work.

Create this texture by lifting thick, wet acrylic off a surface with a piece of cardboard

Acrylic's plasticity makes it uniquely suited to unusual techniques such as weaving strands of dried paint

29

COMPOSING YOUR IMAGE

IF YOU ARE RELATIVELY new to painting, deciding how to compose your image can seem daunting when faced with the wealth of detail in the scene before you. It is important to remember that a painting is a selective personal response to a scene and it allows you to focus on what seems important about it to you and to leave out extraneous details. How you then decide to handle your chosen subject matter in terms of color and technique will very probably relate to questions of mood and atmosphere, in addition to your own level of expertise.

Canal scene

An inner city waterway with a canalboat tied up against the bank makes a good starting point for a composition. When you come across a scene like this, your eye is going to be caught by the boat and the water rather than by the line of cars parked close by. Asked to recall the scene, you would no doubt describe those elements that set it outside of your every-day experience.

YOU DO NOT have to use a camera to record possible angles and viewpoints for your painting. It is just as good to make a series of fairly rapid pencil sketches. These automatically eliminate extraneous detail and allow you to explore the broad outlines of your subject. You will quickly begin to see whether something is going to work or not. However, if your time is limited, take photographs and make pencil sketches from them to help clarify the image in your mind.

CARDBOARD VIEWER

Use two lightweight cardboard L-shaped corners to crop into your drawing or photograph and see how the composition can be varied by focusing on a single element, and leaving others out.

A viewer gives you flexibility when composing your image

L-shaped corners

Use a viewer out on location to help focus on a particular viewpoint

Pencil sketch

This preliminary sketch concentrates on the main areas of the subject. The way it sits on the pages of the sketchbook gives the first indication of how it might look as a painting. Unless you propose to make an extremely complex painting with a great deal of fine detail, you do not need to reproduce every feature in these preliminary pencil studies.

Colored sketch

Making a few drawings in color serves as a reminder of the colors in the scene and opens your eyes to the color possibilities in your final composition. Colored pencils are easy to carry with you. The kind that are water-soluble can be dampened and used a little like watercolor if you also take along a small soft hair paintbrush.

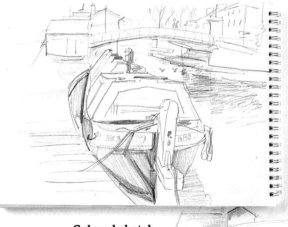

Considering your composition

Many artists who work up paintings in the studio take a series of photographs from which they can select what seems to be the best viewpoint. If what attracts you to the image is an atmospheric quality which seems very difficult to pin down, it can be worthwhile writing a few notes to try to clarify your ideas.

When you are working on a composition, carefully consider your point of view. Are you looking down on it or up at it? How different is the subject going to be in mood and appearance according to this changing viewpoint? How much of the subject do you want to include? Do you want a panoramic view or do you want to focus in on a particular area of a scene? Make sketches from as many angles as possible. Finally, ask yourself what it is that attracts you to the image and then decide on the best way of expressing it in your work.

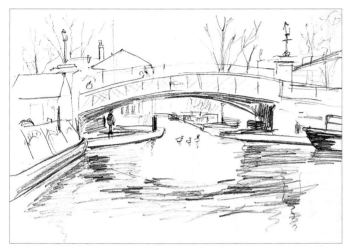

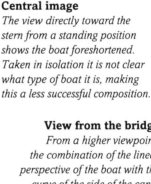

Sitting ducks

Three ducks in conversational mode make an interesting close-up composition drawn from the larger scene (left).

Panoramic view

The image above embraces a wide view of the scene, with the arc of the bridge spanning the composition. The scene opens out in the foreground but the water flowing into the picture draws the eye toward a distant point below and beyond the bridge, just above the center of the composition where the sides of the canal converge.

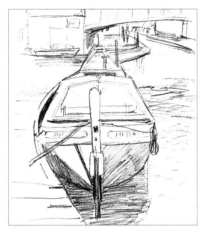

Central image

The view directly toward the stern from a standing position shows the boat foreshortened. Taken in isolation it is not clear what type of boat it is, making this a less successful composition.

View from the bridge

From a higher viewpoint, the combination of the linear perspective of the boat with the curve of the side of the canal and the standing figure creates an unusual and interesting scene.

Details from the photograph opposite, such as the parked cars, have been left out so that they do not detract from the main image of the canalboat.

Placing the boat to the left of the painting establishes a proper balance in the work. Interesting reflections in the water on the right help to create a work with stillness and poise.

The finished painting is quite accurate in its depiction of the original scene although the boat has now become more of a focal point.

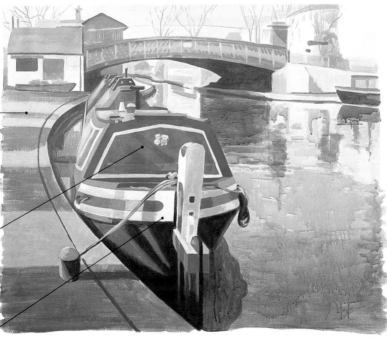

The finished painting

This takes in the arc of the bridge, the curve of the side of the canal, and a view of the finished boat. This demonstrates its length and also celebrates the chunky wooden rudder arrangement at the stern. It combines a close-up view with a long view, giving the boat a prominent position.

TRANSFERRING YOUR IMAGE

THERE ARE A NUMBER of ways of transferring an image onto your support before you start painting. You can, of course, start making the painting directly from life onto the canvas without producing any preliminary studies. However, many artists prefer to use a sketch or a photograph as a guide to drawing in the broad outlines of an image. It is at this point you can start to rethink the composition after consulting all your reference material. If your image is to be used at the same size, trace it onto the support in the normal way. With canvas, you can trace your sketch, run a spiked artists' wheel over the traced outline and then pounce (dab) charcoal dust through the holes in the tracing paper onto the canvas. To scale up an image, either use a grid, enlarge it with a slide projector, or judge it by eye.

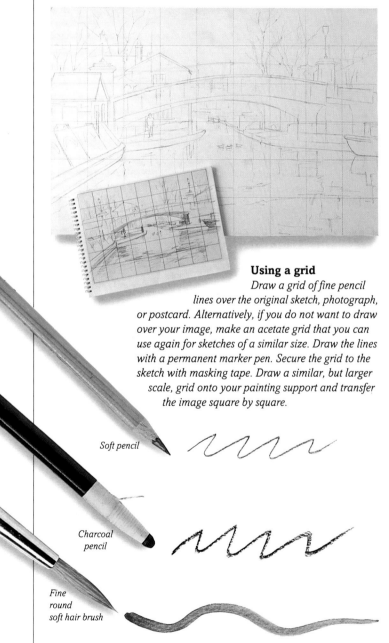

Using a grid
Draw a grid of fine pencil lines over the original sketch, photograph, or postcard. Alternatively, if you do not want to draw over your image, make an acetate grid that you can use again for sketches of a similar size. Draw the lines with a permanent marker pen. Secure the grid to the sketch with masking tape. Draw a similar, but larger scale, grid onto your painting support and transfer the image square by square.

Soft pencil

Charcoal pencil

Fine round soft hair brush

Sketching with a brush
This method (below) *can be used when working from life, but is more usually used when translating the image from a sketch to the support. Sketch out the broad outlines of the image with a thin round soft hair brush and a well-diluted wash of Burnt Umber. For a large-scale work, a brush such as a filbert is preferable, used on its edge for finer lines and on the broad side for indicating broad tonal areas.*

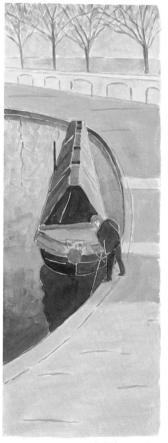

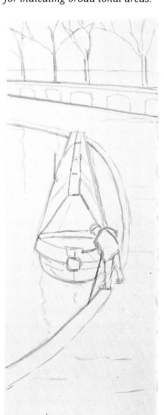

Adding color
Show just enough of the image in the sketch to feel confident about filling in the broad areas of tone and color in the initial painting stages (above). *Keep these tones pale or even monochromatic but with sufficient tonal range to show the difference between the highlights and the areas in deepest shadow. You can either make use of the lines of the sketch in the finished work, or overpaint them.*

TRACING IS PROBABLY the easiest method of transfer, providing the reference and finished work are to be the same size. Using tracing paper, trace over the image, then draw over the lines on the back with a soft pencil. Reproduce the image on your support by shading over the top. A spiked wheel and charcoal dust makes it easier to trace onto textures such as canvas. Paint over the faint charcoal outline with dilute paint.

To scale up images by using a grid, copy the contents of each square of your grid onto the larger squares of your support. If you are enlarging by using a slide projector, work in a darkened room, with a projector that will not overheat. Project a slide of the image onto the canvas and copy it by following the projected outline.

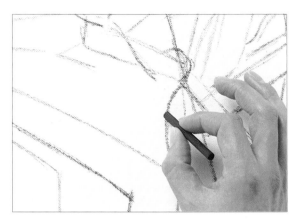

1 ◀ If you are happy to scale up your image from the sketch onto the support by eye, then you can use a traditional method of transferring your image – drawing it with charcoal onto your support. Use either sticks of charcoal or a charcoal pencil, which is less messy.

2 ▶ Use a soft cloth to rub off the charcoal drawing, remembering to make sure that you brush off all the dust before you start to apply paint. The marks will remain as a guide, but the charcoal dust will not blacken any paint that you apply subsequently.

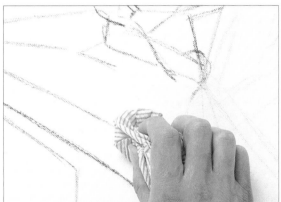

3 ▲ Using a small round soft hair brush and diluted acrylic color, paint in the outline of the image. Choose the colors that you will be using to complete the image, so that they can act as a guide while you are working.

Canalboat stern
The color guides laid down before (above right) have been worked up and now the richness of the color in the painting makes the white sing out. The finished composition – a detail of the stern of the canalboat – is so stylized as to appear almost abstract. The mooring rope leads the eye straight into the center of the painting.

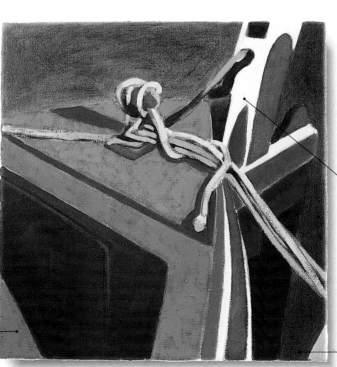

Scumbles of opaque pale blue over much darker blue give solidity to the form of the boat.

Surrounding the well-defined red and blue areas with white intensifies our perception of these colors.

A transparent wash of dark blue over a lighter hue gives richness and depth to the shadows.

Materials

Stick of charcoal

Round soft hair brush

Soft cloth

33

LIGHT, SHADE, AND TONE

TO PAINT AN IMAGE you need to know about form. This knowledge will allow you to give depth and three-dimensional shape to your painting. Form is created by the effects of light and shade on the image. Making a monochromatic study – a painting in different tones of a single color – is a useful exercise to help you appreciate how this works. It allows you to concentrate on the lightness and darkness of tones without having to worry about getting the colors right.

Monochrome sketch
This quick sketch blocks in the tonal areas, to be re-created more subtly in further studies.

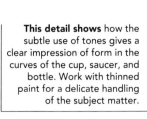

The highlights on the bottle, indicating the direction of the light source, are created by applying Titanium White. To describe the curve of the bottle shown in this detail, make use of the full range of available tones, graduating from light through to dark.

IT CAN BE DIFFICULT to separate the idea of tone from color. Take a plain sheet of white or colored paper, twist it up, and place it near a light source. Although the paper remains the same color throughout, it is broken up into a wide range of tones, from dark to light. Try making a study of it. You could also make a still life out of simple objects such as stones or old bottles. Paint the objects with white emulsion and stand them on white paper, with white paper behind them. Shine a light on them from one side, and consider how the variations in tone give you a fully three-dimensional image of the objects. Make single-color studies from this, working both on a white ground with thinned paint and on a toned ground with the addition of Titanium White.

Working on a toned ground
Prepare the canvas first with a light tone of blue, made by mixing in Titanium White. Paint in the dark tones and the light tones, allowing the toned ground to provide the mid-tones.

Working on a white ground
Produce the lighter tones by simply thinning down the paint – in this case Burnt Umber – and using the white of the ground to provide the highlights.

This detail shows how the subtle use of tones gives a clear impression of form in the curves of the cup, saucer, and bottle. Work with thinned paint for a delicate handling of the subject matter.

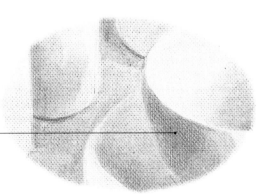

34

Chili peppers

Making studies in color

Learning to reproduce a solid object as an image with form on a flat surface requires practice. When you are fully confident working in monochromatic tones, move on to color, bearing in mind the lessons you have learned about the subtleties of light, shade, and tone.

1 ▶ Lay down a mid-tone of green so that you can work the color up and down to provide the highlights and shadows that will give form to the peppers. Using a violet wash for the shadows gives them a more obvious presence than in the original, enhancing the color of the green.

2 ◀ Working with transparent washes, use deeper tones of green to mold the edges and the indentations of the pepper, starting to give it form. Soften the edges with a clean, damp brush. Leave some areas of the original ground color exposed, although little of this may survive in the finished work.

3 ▲ Mix a lighter green to give form to the stalk and use it to add to the curves of the pepper. White highlights on the upper surface of the pepper show the direction of the light source.

The use of the opaque mid-tone ground as a starting point for the painting of the chili peppers produces a substantial three-dimensional effect with only the most economical over-painting in thin washes.

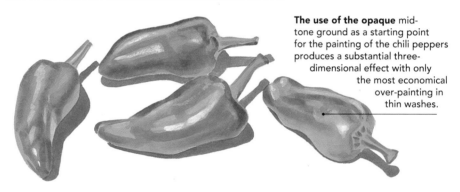

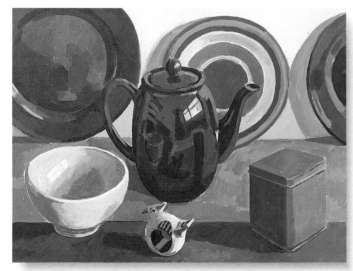

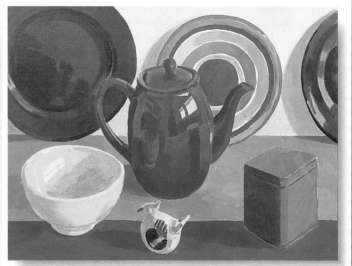

Working in monochrome

Such a range of tone is used in this work that it almost seems to be in full color. The coffeepot is especially effective, and images reflected in it help to give it form. A sense of light coming from the right is very strong.

Working in color

When you translate the same still life into color, use the monochromatic study as a guide. The tones that were dark or light now become the light or dark hues of a color, but the shadows are more subtly expressed.

GALLERY OF COMPOSITION

COMPOSITION IS THE ORGANIZATION of the pictorial space in a painting. You can organize forms in order to tell a story, create a mood, or convey a meaning. Try changing the viewpoint: looking up at an image may make it seem to loom over us; looking down on it makes it unfold like a landscape in front of our eyes. Cram things into a work to give a sense of claustrophobia, or open the space out to make it seem part of something larger. You can focus either on specific areas or on the work as a whole. Most artists strive for an overall balance, but there are no rigid rules – as these varied examples show.

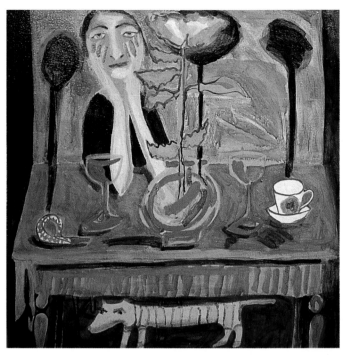

Jo Kelly, *Rose Face* *36 x 36 in (91 x 91 cm)*
In this bold and striking composition, the table top dominates the canvas, pushing off the picture plane toward the viewer so that it feels as if we are actually sharing a glass of wine or a coffee with the subject.

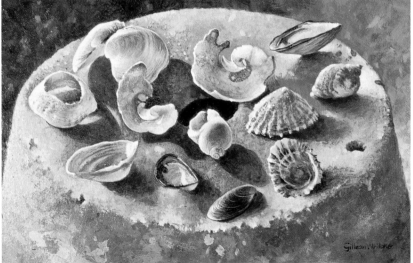

Gillean Whitaker, *Seashells on Flower Pot* *36 x 72 in (91 x 183 cm)*
Here, the composition is contained within the frame, with the shells carefully and consciously arranged within the ellipse of the flower pot. The composition makes us look at the shells as attentively as if we were children inspecting the contents of the nature display at school. Whitaker's shells sit bright and alert in the sun, with the warm, golden yellows complementing the touches of purple. The dark shadows that the shells cast on the flat surface of the flower pot help to add to our awareness of their three-dimensional substance.

Patrick Caulfield, *Lunchtime* 1985
81 x 96 in (206 x 244 cm)
We get more of a real sense of this interior because the painting is not bounded by conventional linear perspective. Caulfield is aware that there are many ways of representing space and light. He opens up a whole series of angles and planes in a semi-symmetrical arrangement that has us looking around corners, behind walls, and through windows in sunlight and at night. The painting also manages to bring together an extraordinary range of acrylic painting styles, without appearing to be disjointed in any way.

Mike Gorman, *Flowerscape* *72 x 60 in (183 x 152 cm)*
In Gorman's attractive painting, the flowers are highlighted in light, opaque tones against both the dark ground and the mid- to dark green tones of the foliage. The choice of traditional subject matter disguises an adventurous composition. The flowers are barely contained within the frame and seem to spill out on all sides. This effect owes much to the angle from which the plants are seen. It is as if we are getting right down among the flowers, much as a gardener might.

Patrick Caulfield's choice of a geranium plant for his "mini-composition" is an effective one. Using the complementaries red and green lends a strength that makes this detail perfectly self-contained.

Jennifer Durrant, *Arrival* *102 x 128 in (260 x 325 cm)*
In this painting, the composition is opened out by the gray-rose backdrop, which appears to float behind all the orange, yellow, and blue shapes that are hovering just above it. Durrant has created this highly effective abstract illusion by giving her composition a very real sense of perspective. Durrant's first step when creating a painting is to stain the canvas with large areas of flat, uniform color. Then she builds up parts of the surface of the painting by using successive layers of thin glazes.

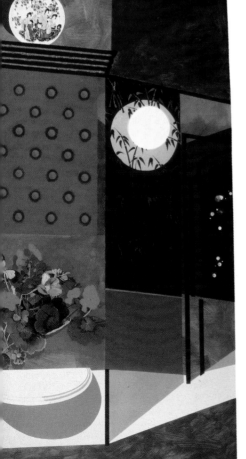

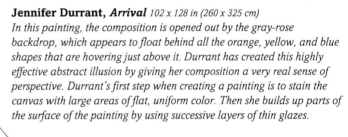

The geranium plant in Caulfield's painting is a good example of a composition within an overall composition. This detail is a closed composition in which the whole of the plant is contained within the rectangular area of the canvas on which it appears. In this carefully painted still-life detail, the effect of the light and shadow on the leaves has been precisely observed.

37

USING OPAQUE ACRYLIC

ARTISTS WORKING in acrylics often use the paint opaquely. This simply means that any overlaid color covers up the color underneath it. Some acrylic colors are naturally opaque – for example, Cadmium Red, Yellow Ochre, and Oxide of Chromium (a shade of green).

Transparent colors such as Quinacridone Red and Phthalo Blue can be made opaque by mixing in a little white or some other opaque color. It is common when using opaque acrylic to work on a toned ground. Areas of the ground can then provide the mid-tones, while light areas and highlights are created by obliterating parts of the ground with pale, opaque paint.

OPAQUE ACRYLIC lends itself readily to a variety of different painting styles. On the one extreme, you can make absolutely smooth, flat-toned paintings in which the actual

Seashell
This vibrant shell is painted in opaque acrylic thickened with gel medium. White highlights are added over other colors. The texture of the canvas support enhances the bold brushwork.

brushwork is invisible. Acrylic paints are particularly well-suited to this style because the medium can be applied much more evenly than other media. Using this approach, each area of color is a well-defined, hard-edged shape, filled in with a uniformly toned flat color. A number of highly influential painters have used acrylic in this way, including Andy Warhol and Bridget Riley (*see* pp.8–9).

A popular method of achieving a clean, often straight, edge, is to use masking tape. Always make sure that you rub the tape down on the canvas with a fingernail to prevent the paint from seeping underneath it.

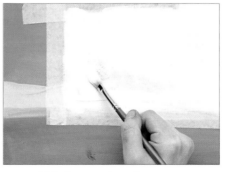

1 ▲ Use masking tape to create a crisply outlined building standing out against a vivid sky in bright sunlight. First, paint in the broad areas of the background fairly evenly with opaque paint, and leave to dry.

2 ▲ Stick the tape down in the shape of the building. Fill this shape in with thick white paint, used straight out of the tube and brushed out flatly.

Materials

No.8 short flat bristle brush

Masking tape

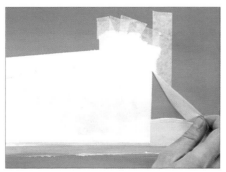

3 ▲ When the white paint has dried, carefully remove the tape. If the edges of your masking tape were stuck down well, a clean-edged image should emerge.

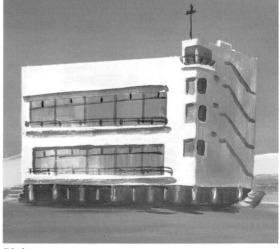

Riviera scene
Tape was also used to add windows. Acrylic makes it easy to paint a shape opaquely over a completed backdrop, instead of having to paint carefully up to the edges of the shape.

Woman sunbathing

Here, the bright, clear colors of a beach scene are painted in opaque mixtures, with the shadows provided either by superimposed dark tones, or by the color of the brown ground. When you use opaque paint on a colored or toned ground, the ground color provides an underlying structure behind the individual brushstrokes. This integrates the work and gives it a sense of cohesion. Mixing white in with the blue used for the towel and the yellow of the sand gives a striking, saturated quality to these colors, making them glow in the sun.

Impasto painting

On the other hand, acrylic is equally good for impasto techniques – highly visible brushwork used with very thick opaque color. This effect is particularly associated with oil paint, but acrylic adds a distinctive texture and color-quality of its own.

Unlike most oil colors, which dry the same color as when they were wet, acrylic tends to dry darker. This may cause color-matching problems if you return to a painting after a break. It can be worth mixing a fairly large amount of a color and keeping it in a sealed jar.

The detail of the sunbathing woman's feet shows how modeling is provided by a range of superimposed tones and areas of exposed ground.

Building up successive layers of color has created a rich, shadowed area in which the glowing red stripes on the towel are just visible.

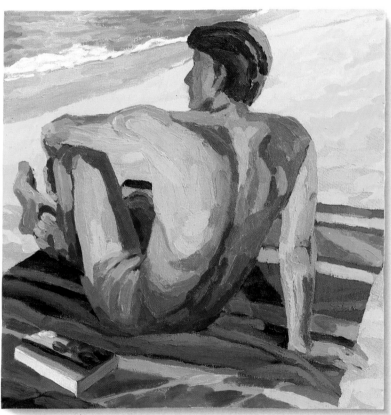

Ridges of thick paint give an exciting texture. When oils are used like this, they may dry on the surface only, and crack. Acrylic is faster-drying and more elastic.

The highly visible brushstrokes have a thick and creamy appearance that reflects an obvious delight in both the medium and the subject matter.

Sea and sand

When you paint with opaque acrylic, you can also enjoy the fact that it can be used very effectively in a thickly textured impasto style. In this vibrant summer scene, figure, sea, and sand are integrated in a rich pattern of warm adjacent colors. When it is used very thickly, acrylic scores over oils in that it dries so quickly – oils can take months to dry.

Texture paste

Various commercial pastes can be added to acrylic to give it extra body and a range of textures. These are ideal for impasto techniques. Because acrylic is an adhesive, it can also be mixed with sand or grit.

OPAQUE PORTRAIT

Initial sketch
Carefully planned in pencil, the portrait was painted on watercolor paper.

IN OPAQUE PAINTING methods, the highlights are provided by the use of opaque white acrylic, and the paler tones by mixing colors with white. Working entirely with opaque acrylic is similar to working with gouache – an opaque form of watercolor paint. However, acrylic scores over gouache in its ability to be overpainted without dissolving the paint layer beneath. This uncompromising, bold portrait has the solid, slightly chalky feel that opaque paint brings to a work. Tonal variation is produced by separate, flat areas of uniform color. The brick wall – parallel to the picture plane and close to the viewer – has the effect of pushing the figure toward us.

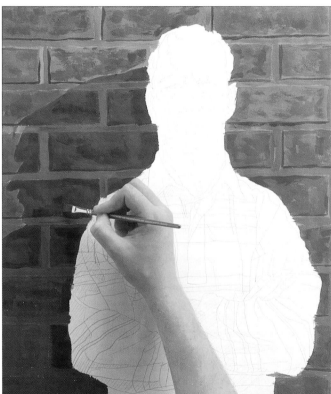

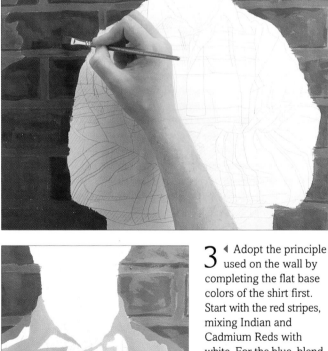

1 ◀ Completing the brick background first helps you to set the tonal range of the painting. Start with areas of flat base color: Cobalt Blue, Yellow Ochre, and white for the mortar; Yellow Ochre, Ultramarine, Indian Red, and white for the bricks; darker brown for the large shadow. Now use dark mixes to tone down the mortar, to outline and add texture to the bricks, and to intensify the shadow.

2 ▶ Turning to the shirt, fill in the green stripes by adding Cadmium Yellow to the basic "mortar" color.

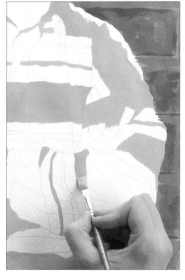

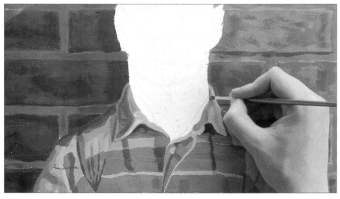

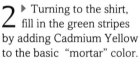

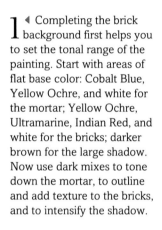

3 ◀ Adopt the principle used on the wall by completing the flat base colors of the shirt first. Start with the red stripes, mixing Indian and Cadmium Reds with white. For the blue, blend Cobalt Blue with white, adding a touch of Yellow Ochre to give a subtle green-blue. As with the wall, crisp definition is given by abutting rather than overlapping areas of different color.

4 ▲ Switching to the ⅛in brush, create detail on the shirt by mixing dark blends for shadows and light ones for highlights. Large shadows are separate areas of color, and small ones are laid over the base colors. However, all the shadows could be overlaid because acrylics dry so rapidly. Adjust colors accordingly. For example, for the blue shadows, use less white and more Cobalt Blue, and add a little more Yellow Ochre to tone down the color.

5 ▶ This strong face is the focal point of the painting, so use a wide range of light, mid-, and dark tones to build up a boldly sculptural shape. Start by laying down a light overall flesh tone that mixes Cadmium Red, Cadmium Yellow, and a lot of Titanium White. Create shadow on the left-hand side of the face by adding a purple-pink mid-tone of Cobalt Blue, white, and Cadmium Red. Define the other side of the face with darker mixes of the basic flesh color.

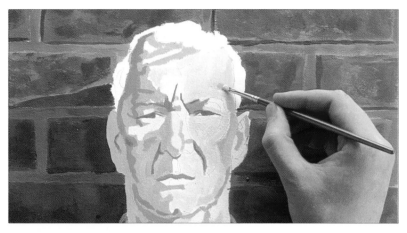

*No.000 round
sable brush*

*⅛ in flat
sable / synthetic brush*

*⅜ in flat
sable / synthetic brush*

*½ in flat
sable / synthetic brush*

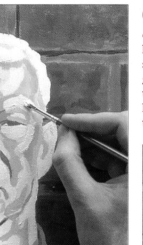

6 ◀ Paint some more mid-tones down both sides of the face. Having established the mid-tones, you can judge which dark purply shade will throw the left-hand side of the face into the most effective dramatic shadow. Now concentrate on the hair, creating a light gray shade by adding a tiny amount of Cobalt Blue to Titanium White. Change to white paint to add the highlights onto the hair, face, and neck, using the paint thickly to give texture and surface interest.

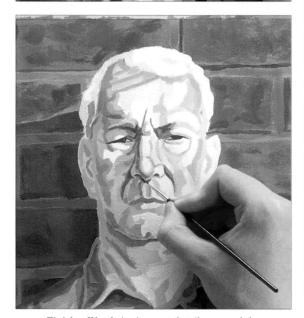

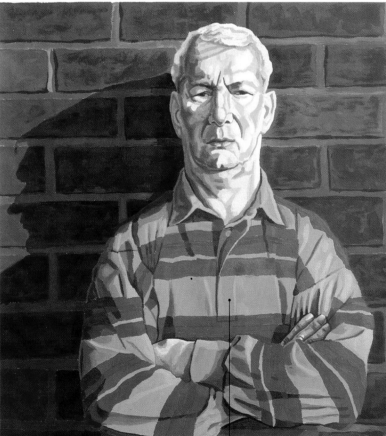

7 ▲ Finish off by bringing out details around the nose and eye area. Load the fine round brush with a dark blend of Ultramarine and a touch of Yellow Ochre – the yellow knocks back the blue, keeping it dark but not as bright. This color gives crisp definition, but is much warmer than black paint, blending in with the facial tones and bringing real strength to the face.

Portrait of the artist's father
The portrait was painted on a highly detailed pencil drawing, which is completely obliterated by the opaque paint. The dense shadow of the figure on the wall adds an element of drama, and the sharp, graphic lines make the figure "leap" forcefully out of the painting.

The shirt's simple, linear pattern brings the figure forward. The use of toned-down primary colors adds strength, but is not overpowering.

*Derek
Worrall*

41

TRANSPARENT TECHNIQUES

MOST OF THE effects associated with watercolor painting can be created using diluted acrylic paints in a transparent technique. These effects include laying in thinned washes of uniform and varied tones, applying color wet-in-wet, and overlaying washes onto dry color to build up deep, resonant tones and colors. This is much easier using acrylic paint because it is insoluble in water when dry; overlaid colors will not disturb the ones beneath. In addition, you can use various resist techniques, including wax crayons, oil pastels, and latex masking fluid.

Transparent effects
Overlaid brushstrokes of transparent color on canvas (top) *have a very different appearance to those on paper* (right). *The pigment particles settle into the hollows of the weave, making the texture of the fabric visible and creating expressive half-tones.*

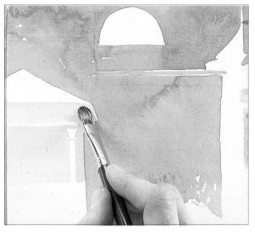

1 ▲ Lay a thin orange wash over the main area of the building, allowing the watery paint to move and flow, creating spontaneous effects. Use Cadmium Yellow Light for the portico and leave the areas to be painted in lighter tones white.

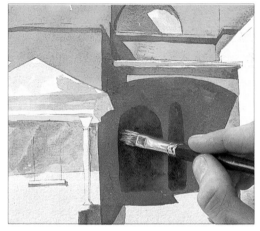

2 ▲ Add blue-gray over the white roof and window area. Use deeper washes to broaden the areas of shadow, adding depth. A blue wash over part of the orange area cools the color here, effectively creating the shadowy arch.

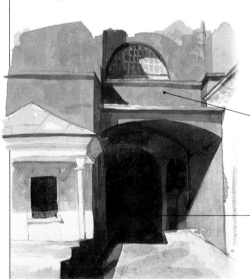

The special quality of transparent acrylic techniques is the beauty and subtlety of overlaid veils of thin transparent color, illuminated by the white paper.

Using deeper tones, dramatic color changes arise from simply painting one color over another.

The warm orange washes bring the wall forward, while the complementary blues make the window recede.

Sunlit window
Laying loose patches of washes in warm tones – orange, apricot, and yellow – gives the impression of a sun-dappled facade. The cool shadows within the window are achieved with blue-purple washes.

Subdued color
The deep blue-purple background is created in the same way as the window (above), but here a low-key approach is used for the brickwork, with washes of Cerulean Blue and Burnt Sienna producing the atmospheric effects.

Sunlight and shadows
The finished picture (above) was built up using washes in varying strengths and mixtures of Ultramarine Blue, Burnt Sienna, purple made with Deep Brilliant Red, Phthalo Blue and Paynes Gray, and Azo Yellow Light (right).

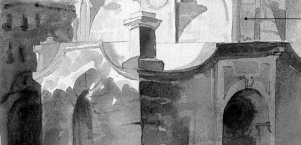

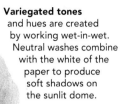

Variegated tones
and hues are created by working wet-in-wet. Neutral washes combine with the white of the paper to produce soft shadows on the sunlit dome.

The purple hues
of the deep shadow on the walls contrasts with the cool pale blue and yellow washes, which create subtle greenish grays on the right of the dome.

Working wet-in-wet
Here, the broad area of shadow is not painted in one tone of a single color as on the previous page, but created using the wet-in-wet technique. Different colors are touched into a wet or damp area of the painting and allowed to mingle and fuse.

Controlling washes
Working successfully with wet-in-wet techniques relies on a balance between control and spontaneity. Limit the effect of the technique by wetting specific areas of color or tone, such as the side of a column in shadow, as here. By dealing with separate areas in this way your paint will move freely within them, but will not run out of control over the work as a whole.

Creating colors
It is useful to know how particular colors interact when you are working wet-in-wet. Practice by producing some color samples first (right). Certain color blends may give a rather muddy result (top). Thin, pale washes can produce an interesting feathery effect, due to over-dilution of the pigment (bottom).

RESIST TECHNIQUES

Because transparent techniques rely on the white of the ground for highlights rather than the color of the paint, you may need to protect parts of your painting to retain highlights or pale areas when you overpaint. A good way of doing this is to use latex masking fluid. Paint it over the area to be protected (use an old brush and wash it immediately). Let it dry, overpaint it, allow the paint to dry and then rub off the masking fluid.

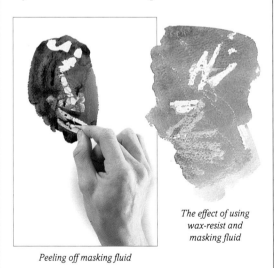

The effect of using wax-resist and masking fluid

Peeling off masking fluid

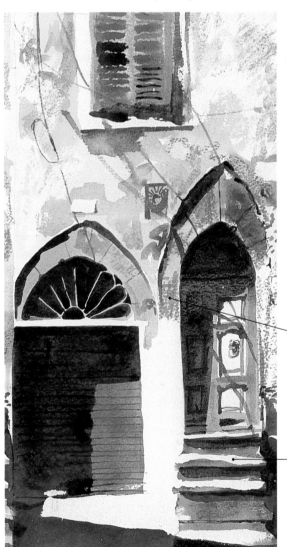

Oil pastels and
wax candles can also be used in resist techniques. The acrylic color will not be completely repelled by them, so they must be incorporated into the finished effect. This painting uses oil pastel on the shutters, the arch of the door, and in patches on the wall, where it shows through the transparent washes of paint.

Masking fluid has been used on the steps and on the wall around the window. When it is removed and the white paper is exposed, it gives the effect of a shaft of strong sunlight falling on the wall.

Windows and doorways
Vibrant colors and deep shadows are typical of scenes painted in sunny climates. Use warm oranges and yellows for colors in sunlight – Cadmium Yellow Light alone and mixed with Cadmium Red Light are ideal. Use cooler greens and Phthalo Blue based purples to lay washes in the area of shadows. Work from light to dark, overlaying washes to deepen tones, and avoid overworking an image.

WORKING WITH WASHES

Painting with acrylics using a transparent technique is very similar to watercolor painting in execution and finished effect. Use the white of your paper to provide the highlights and to illuminate all the other colors and tones in the composition. For the pale tones, thin the paint with a lot of water to make fine washes of well-diluted color. Create dark tones by mixing deeper washes, or by overlaying washes.

In this painting, leave the white of the paper showing through for the areas in bright sunlight, such as the dome, the side of the building, and the foreground pavement area. Deepen the tones for the areas in shadow – warm to the left and cool to the right – to produce a convincing but still loose and relaxed impression of this city scene.

Photographic reference
When working from a photograph, there's no need to faithfully reproduce all the details; use it as a point of reference for your central image and change the details as you choose.

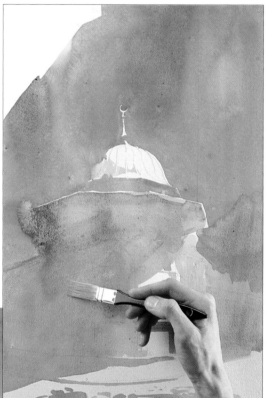

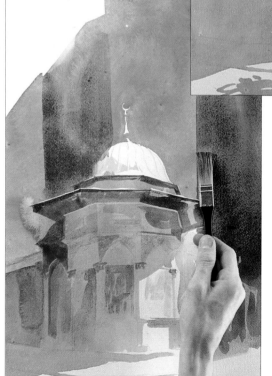

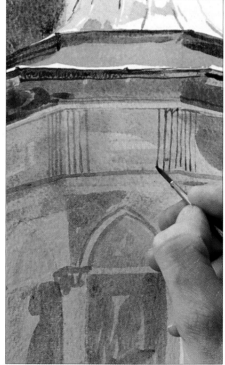

1 ▲ Use a large synthetic wash brush to lay a medium blue wash over part of the background. The white of the paper provides the sunlit dome; choose a No.2 round brush to work in the details. Using Raw Sienna, blending wet-in-wet with Burnt Sienna, start to lay in warm shadows on the left.

2 ◀ Mix Deep Brilliant Red and Cerulean Blue for the purple-violet shadows on the walls, which begin to give structure to the building. Lay a wash of Olive Green, French Ultramarine, and Burnt Sienna, using a flat wash brush to suggest the shadowy buildings in the background.

3 ▲ Deepen the shadows on the edge of the canopy of the dome with a purple made from Deep Brilliant Red and Phthalo Blue. Shade the arches and start to pick out the details of the windows using a No.6 round brush with dilute Raw Sienna. Paint in the fine architectural details above them with a No.2 round brush.

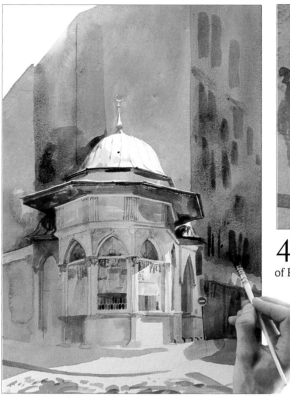

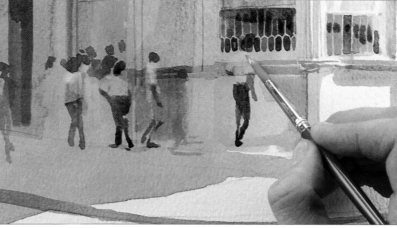

4 ◀ The facade of the building takes shape with a mixture of Phthalo Blue and Olive Green, used to add detail to the windows. Select Cadmium Red for the street sign and suggest the windows of the buildings in the background with a No. 6 round brush and a wash of Phthalo Blue.

5 ▲ The passersby appear as if by magic – start with a dab of color for the head and use Titanium White as a transparent overlaid color to build up the upper halves of the bodies. Use a selection of neutral grays, browns, and purples already mixed on your palette to add the legs. Note that Titanium White, when overpainted onto brown, has a bluish cast in comparison to the white showing through from the paper elsewhere in the painting.

Work of this kind relies on a balance between areas of free-flowing washes and finely worked details for its effects. You need just enough of the latter to define the image but not too much to crowd it.

Architectural study, Istanbul

The use of highlights from the background color of the paper gives a convincing impression of light flooding down in front of the building and reflecting back off the pavement. Overlaid transparent washes are entirely responsible for the form of the building and its surroundings; the precise architectural detail has been drawn in with a fine brush. The people are both strangely insubstantial and a powerful presence; their sense of movement is created by economic brushwork building up washes of color.

The finished background is just suggested with washes and the merest hint of detail so that the central image becomes more powerful.

The original photograph is re-interpreted, using artistic license. Notice how the people in the foreground have been dropped, and the background buildings changed subtly. Too much extraneous detail detracts from the central image and is also hard to interpret.

Materials

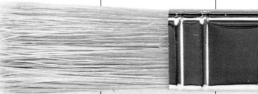

No.2 round sable brush

No.4 round sable brush

No.6 round squirrel brush

Synthetic wash brush

Julian Bray

GALLERY OF PAINTING STYLES

THE VERSATILITY OF ACRYLIC paint means that it can be used in a wide variety of ways. When highly diluted, acrylics produce attractive watercolor-type effects on all kinds of different painting surfaces. Acrylic paints may also be used semi-opaquely and opaquely, or very thickly – creating the kind of impasted work that is traditionally associated with oil painting. These very different paintings show how some artists working in acrylics use just one approach to great effect, while others combine several approaches in one painting.

Christopher Lenthall, _Untitled_ 60 x 60 in (152 x 152 cm)
This painting has the quality of a Pop Art print and clearly demonstrates the artist's interest in typography. A bright, flat effect is achieved by applying opaque paint onto the canvas very evenly, and by using colors right out of the tube, without any mixing. The pale blue ground is actually toned primer. To create his patterns, Lenthall uses stencils to produce an outline that is then filled in with color.

Gabriella Baldwin-Purry,
Karen 21 x 29 in (53 x 74 cm)
This largely monochromatic painting is done exclusively in a transparent watercolor technique. Its immediacy arises from a loose, liquid use of the medium, with the white of the paper support illuminating the thin washes.

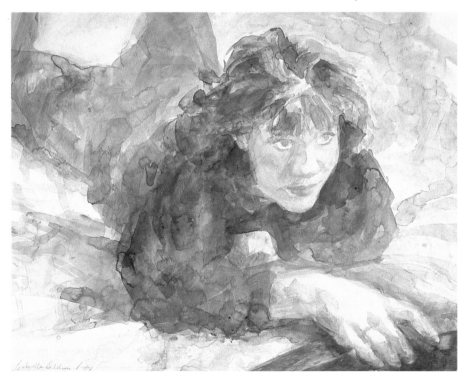

Jane Gifford, _Burmese Puppet_ 39 x 25 in (99 x 65 cm)
Here, thin transparent preliminary washes have been combined with superimposed touches of thick, opaque color. The latter cover almost the whole surface, giving it a richness that echoes the costume's ornate decoration. The work is an unashamedly exuberant confection.

David Evans,
Pier and Old Lighthouse

3 x 4 in (8 x 10 cm)

Evans' appealing and accessible seascape is painted almost exclusively with an opaque color technique, in which colors are mixed with white to lighten the tone and the paint is applied relatively thickly. This has given the painting a solid and rather melancholy atmosphere. The work is deceptively simple; it seems almost naive. But the artist's use of color is sophisticated, with all the low-key hues enlivened by a carefully placed touch of orange-red on the lighthouse tower. Evans has achieved a sense of great breadth in what is actually a tiny work.

This detail shows how the stripes of pink, orange, pale green, apricot, and pale blue have been painted in one thick, bold brushstroke each. In doing this, the artist is exploiting the opaque possibilities of acrylic paint – the way in which it can totally obliterate colors underneath.

Albert Irvin, *Madison*, 1990

34 x 48 in (86 x 122 cm)

Irvin's work has always celebrated the expressive possibilities of the paint itself. This painting is no exception. It gets involved with acrylic color in a vital way, combining sweeping strokes and pure color in a spirited, vigorous composition. The opacity of the color mixes allows parts of the work to be overpainted with a single brushstroke.

John McLean, *Avalanche*

58 x 91 in (146 x 231 cm)

This artist's paintings have a deceptive simplicity of appearance while showing an extraordinary control of the acrylic medium. He uses the paint in thin, transparent washes, often applied to unprimed canvas to give a soaked-in look that makes an intimate bond between paint and support. This "star-burst," in vibrant adjacent colors, has an exciting freshness and vitality.

DRY-BRUSH AND SCUMBLING

WITH DRY-BRUSH TECHNIQUES, interesting textures are created by practically scrubbing paint dryly onto your painting surface. This is often done with a bristle brush, and over a textured ground: the ridges of the surface take the paint, and the hollows are left in their original color. Dry-brushing is particularly effective over another color. Achieve the necessary "dry" brush by wiping it on a rag before painting. In scumbling, thin or thick semi-opaque color is brushed loosely over another, dried, color. The color beneath the scumble may show through in places, so that it still has a significant effect on the final result.

WHEN DRY-BRUSHING with thin acrylic, remove excess paint and moisture with an absorbent rag or paper towel. With thick paint, commonly used for dry-brushing, fill the brush with stiff paint straight from the tube before working it on your palette or on a rag. Try dry-brushing opaque light paint over a textured, colored ground, or dark color over a white ground. Halftones emerge where the paint is left on the ridges, with the ground still showing in the dips and hollows.

Pueblo village
Here, forms and shadows were painted in specific colors, and then very different colors were dry-brushed over the top. Dry-brushing a cold blue or purple over the hot yellows and oranges creates rich, deep shadows. The ladders have been added with the lightest of touches, using a very rapid dry-brush technique.

Dry-brushed cacti
The cactus above is painted on canvas board. It shows how any rough surface – paper, board, or canvas – is a very effective base for dry-brush techniques. On a smooth surface, such as the smooth paper used on the left, you will have to rely more on skillful use of a very dry brush.

Sample scumbles
A huge range of effects can be achieved with scumbling. Vermilion scumbled over Cadmium Yellow is visually different than yellow over Vermilion. Light tones scumbled over dark colors give a subtle depth.

Form and color
The rapid creation of halftones made possible with dry-brushing means that it is ideal for underpainting – for example, sketching in the basic modeling of forms.

Scumbling is important because it allows tones to be lightened and colors to be adjusted in a unique way. An effective use of scumbling is to underpaint an object in one color and then scumble the final color loosely on top. Another alternative is to underpaint in a dark color and scumble a lighter, opaque version of the same color over it.

Chameleons

This exercise shows, very clearly, the difference between scumbling opaque color loosely over a light- and dark-colored ground. On the bright yellow ground, the colors seem dark in tone, while the same colors on the dark blue ground appear lighter. The lively interaction of color that occurs within the dark outlines of the chameleons is a good example of the rich effects that can be obtained with scumbling.

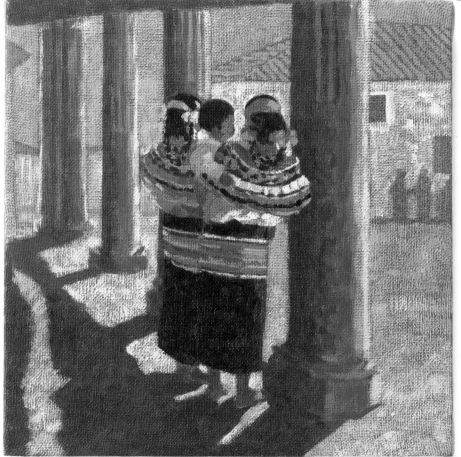

Mexican women and child

This Mexican village scene shows how well dry-brushing and scumbling can work together. Here, the rough weave of the canvas – given a warm orange-brown – provides the perfect backdrop for both the subject matter and the style used. On the dry-brushed areas, paint has been carefully stroked, rather than scrubbed, across the canvas. The shadowed areas were created with a fairly dry scumbling technique.

Dark blue scumbles create shadows on the pillars, the ground, and the women's skirts. Enough of the brown ground shows through to give the work an overall harmony.

Thick, dry opaque color, stroked across the ridges of the canvas, brings out the dazzling effects of sun on the white facade of the far building – and on the ground.

BLENDING

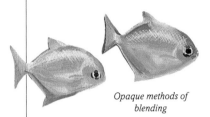

Opaque methods of blending

BLENDING IS MAKING one tone or color flow smoothly into another without an abrupt transition. You can blend colors physically or optically. With physical blending, you actually mix colors. With optical blending, colors are juxtaposed and superimposed – for example, by using dots of color or by cross-hatching – so that, visually, they appear to blend. When working with opaque color, you must work fast before the paint dries, blending with a clean, damp brush. It is easy to create smooth transitions when blending transparent color. You can apply washes to damp paper, drop color onto damp paper to create star-burst effects, or blend with a damp paintbrush.

BLENDING OPAQUE COLOR requires fast work because of the short drying time involved. With transparent color, build up tonal gradations in thin, superimposed layers of color, softening the tone each time with a clean, damp brush. Alternatively, dampen the paper so that the paint fuses into it, becoming lighter in tone.

Coral reef fish
This study incorporates all the methods of blending described here, with the soft fusion of wet areas of transparent color and the more physical blending of opaque color. Cross-hatching is shown by the plants on the left, and gradation of tone by the stippled coral.

Opaque blending
Working on canvas board, different tones of orange are applied adjacent to one another. While they are still wet, the join between them is stroked with a damp, clean brush to smooth the tonal transitions.

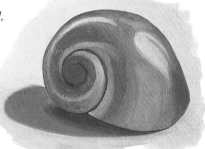

Cross-hatching
Applying acrylic colors in thin lines, as if shading with a pencil, is a method of blending which relates to early Renaissance techniques. You can build up tones and forms and blend colors with fine, cross-hatched strokes. Although this may seem a laborious method of working, the results are very effective.

Dabs of color applied over wet washes create the texture of the coral.

Using transparent color, blend the stripes with a damp brush.

Blending with a damp brush
Apply transparent color to one arm of the starfish, then immediately diffuse the color by running a clean, damp paintbrush along the center of the arm. Create the shadow by using a damp brush over the washed-in color in the same way.

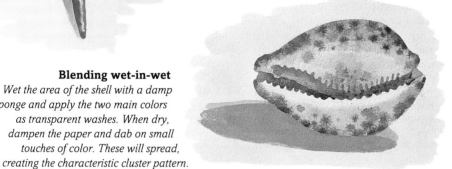

Blending wet-in-wet
Wet the area of the shell with a damp sponge and apply the two main colors as transparent washes. When dry, dampen the paper and dab on small touches of color. These will spread, creating the characteristic cluster pattern.

SOFTENING TONE

● Using a thick round brush, apply a broad sweep of transparent color to the paper *(top)*. Right away, use a clean, damp brush to soften the hard edge.

● Washes applied to damp paper *(below)* depend for their effect on the wetness of the paper.

Blending with a damp brush

Washes on damp paper

Wet-in-wet blending produces subtle colors on the rocks.

Blending on wet paper
Dampen the area within the pebble with a wet sponge, and then wash in the colors so that they fuse and blend naturally. Vary the amount and dilution of the color as you apply it. Use thin lines of opaque color to create the striations on the pebble.

Optical blending
Apply small and uniformly sized touches of pure color straight from the tube to model the tones and colors of the starfish. Juxtaposing blues and orange-reds creates darker-toned shadows among the neutral colors.

AIRBRUSH BLENDING

Blending with an airbrush produces a very smooth tonal transition. It can be useful if you are blending a large area, but is harder to control for smaller details. This strip *(below)* was produced by airbrushing first with yellow, then airbrushing Burnt Sienna over half of it. The deeper tones were achieved by working over the same area several times.

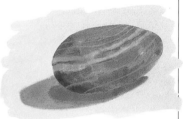

Use a damp brush to blend the stripe of opaque color.

Optical blending creates the stippled effect of the coral.

GLAZING

GLAZING IS THE APPLICATION of a thin layer of transparent color over certain areas, or all, of a painting in order to create specific color effects. You might choose to glaze a single color over the whole surface of a work, as a way of creating a dominant overall hue.

Alternatively, you could use glazes to alter the color of individual objects that have already been underpainted.

BECAUSE ACRYLIC DRIES quickly, you have only a short wait before a glaze can be applied over the top of another color. A glaze is usually modified on the painting surface, to reduce it to a thin, even stain. You must work swiftly and decisively, before the paint dries, and so it is a good idea to glaze one small area at a time. Mix the color to a thin consistency and apply with a brush. Leave it for a minute or two, and then work it over with a dry bristle brush or a shaving brush.

Changing colors
Here, bright green grass has been toned down by adding a very thin red glaze. One layer of glaze is sufficient to break the green; additional layers are too extreme.

Overall glazes
Glazing a whole painting is like putting a color filter over a camera lens. This landscape has been "cooled down" by a blue glaze, applied with a brush (left), and an airbrush (right). To prevent airbrushed paint from running, spray a fine mist in stages and allow each stage to dry.

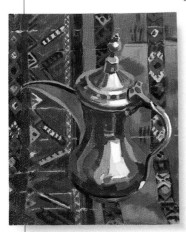

1 ◀ This exercise shows how a painting can be subtly transformed by the application of glazes. Here, the coffeepot has been painted in a full, rich range of tones and colors and is waiting for the addition of glazes to pull the image together. Remember to keep your brush dry by wiping it off on absorbent cloth or paper each time you work over a glaze.

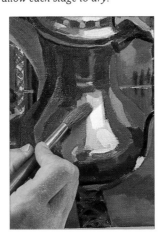

2 ▲ With a No.10 brush, apply a thin wash of Yellow Ochre and gloss medium as a uniform stain over the coffeepot. This enriches the color of the brass and unifies the object.

3 ◀ Create a shadow around the pot with a glaze of Ultramarine and gloss medium – applied very thinly, so that it does not kill the warmth of the red kilim.

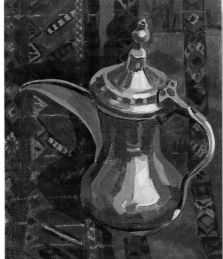

Jane Gifford

Turkish coffeepot and kilim
In the finished work, a film of Indian Red and gloss medium has been added over all of the kilim with a flat 1in brush. This tones down the background, adds warmth and harmonizes all the colors. After glazing, the painting has a mellower, richer look that is ideally suited to the subject matter. The exotic pot and rug seem to glow, as if under artificial light.

Materials

No.12 round sable/synthetic brush

1in sable/synthetic brush

Basic pointers for glazing

When you are glazing, use naturally transparent pigments (*see* p.38) or dilute more opaque ones so that they appear transparent. You can also dilute paint, without losing body, by mixing a very small amount of color with acrylic gel or gloss medium.

You do not have to use a brush. If you are glazing with a tinted acrylic gel medium, you can scrape glaze on in an even film with a piece of flexible plastic such as an old credit card.

Learning how specific colors work together will enable you to create rich, unusual effects. A blue glaze over yellow produces a green that could not be copied by physically mixing a yellow and a blue. Experiment with multi-layered glazes so that you are ready to use them when they seem appropriate to a particular work.

One interesting option is to glaze over images underpainted in monochrome tones such as brown and white or gray and white, or to underpaint in a paler, opaque version of the glaze color. As a general rule when glazing, your underpainting should avoid the darkest and lightest tones.

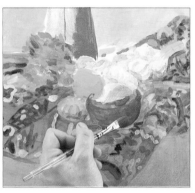

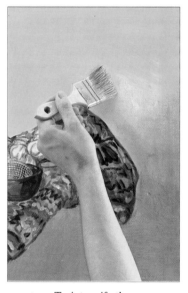

1 ▲ Use glazing to build up large areas of color and more intricate patterns. Block in the underpainting: semi-opaque Cadmium Yellow for the background; glazes of Alizarin Crimson and Cadmium Orange over the dried yellow for the rug; and a Cerulean Blue glaze for the parcel.

2 ▲ When the base colors are dry, glaze shadows over the blue parcel with a Phthalo Blue-based purple. Now build up the rug pattern, and give body to the objects, with layers of glazes.

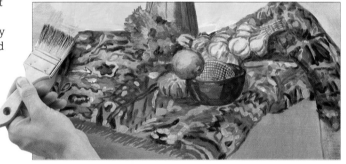

3 ▶ Mix up highly diluted Cobalt Blue with gel medium. Using the large, flat brush, glaze this very transparently over the background yellow to produce shadows on both sides of the painting. Blue creates deeper, warmer shadows than gray or black, harmonizing well with the vivid yellow. Continue to add fine detail by layering glazes.

4 ▲ To intensify the background, add an overall glaze of Cadmium Yellow with the large brush. This now balances the saturated color of the orange foreground – created by glazing Cadmium Orange over the yellow background. With large areas of glaze, work quickly and deliberately to ensure even coverage.

Glowing glazes

The painting glows with colors built up from successive glazes. Adding an extra Cobalt Blue glaze has deepened the side shadows.

The garlic was painted by adding very fine glazes over the white priming of the board support. Letting the intense white primer shine through glazes gives the garlic a subtle translucence and a well-modeled presence.

Ian McCaughrean

Materials

¹/₂ in flat soft synthetic brush

2in bristle brush

THE ALLA PRIMA APPROACH

ALLA PRIMA – MEANING "AT FIRST" in Italian – is an approach to painting that has been popular in oil painting since the 19th century. It is equally relevant to acrylics. A painting made using this method is not generally built up in layers with long gaps between painting sessions. The work is effectively created during one continuous session, normally from life, and there may be little or no preliminary drawing. The advantage of the alla prima method is that, at its best, it conveys an immediacy of mood and style that can give it an exhilarating freshness. In practice, this does not mean that you must get it right the first time. With oil paint, you have to rub off an area before repainting. However, because acrylics dry so rapidly, you can overpaint almost immediately.

Opaque study
Here, the chair receives a chunkier, opaque treatment. Relatively stiff acrylic is applied to the paper using a dry-brush method in which the paint takes hold of the ridges of the paper but misses the hollows, giving a rich texture. As in the other study, the white ground is used as a positive element. Wipe brushes thoroughly on a rag after each rinse, so that they remain dry and the paint does not blot.

Rapid washes
This loose study, on thick watercolor paper, is a boldly direct response to the sight of a jacket casually draped over the back of a chair. The paint is used well diluted, in a watercolor-type technique – separate washes retain their shape and color but flow and blend with one another in places.

KEEPING YOUR PAINT WORKABLE

One of the problems with acrylic paints – especially when working outside or in hot weather – is that they may dry so rapidly that you do not have time to manipulate them on your painting or even on the palette. To avoid this: make sure that you only squeeze out the amount of paint you need at any one time; keep spraying the palette with water; mix a proprietary "retarder" with the paint; or use a special "stay-wet" palette *(below)*.

Spraying a palette with a fine water mist to keep paint moist

Commercial "stay-wet" palette, lined with special paper that is dampened before paints are squeezed out on top

VERY OFTEN, ALLA PRIMA paintings are made outside, in the landscape. However, the alla prima approach is equally suited to any work where you want to achieve a fresh, spontaneous feel. In order to get used to this painting method, perhaps as a way of practicing before you venture outside, try doing some simple still lifes of objects around your home, like the studies shown on these pages.

If you are planning, for example, to tackle a scene featuring people, you might want to make some transitional studies of a figure, or small groups of people, such as the brisk sketch of the two flower-sellers on page 55.

Using a colored ground

You can use alla prima techniques equally effectively on a colored ground. In the painting on the left, the dark tones of the hat and shoes create a striking physical presence on the pale pink ground. The ground was painted and allowed to dry before the other main areas were blocked in roughly, in a free, abstract way. As a final step, detail was added and the boots were outlined rapidly with a mix of Burnt Umber and Ivory Black. Notice how flecks of color from one object are reflected on another object – a quick, easy touch that gives the study a satisfying unity and harmony.

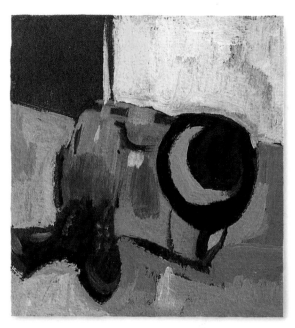

A darker ground

Here, all the paper was painted with a mix of Ultramarine and Phthalo Blue first, applied flatly and evenly. This basic ground is left exposed in the top left-hand corner, and gives added depth to the yellow and pink tones, which are scumbled thickly over the top (see pp.48–49).

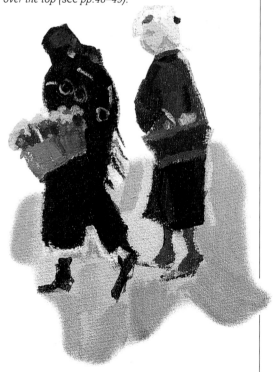

A study in bold brushwork

This study shows the immediacy of decisive brushwork. Mainly flat brushes were used, with their typically broad strokes. The opaque paint is creamy in texture. If just a little more water had been added, the artist would have been mixing paint on the actual painting (which is best avoided, although it has occurred in the dark beige area to the right of the hat). The work has a genuine alla prima feel; painted very rapidly, it was completed before any areas could dry. Like the other sketches, it is all about playing with abstract blocks of color before adding final defining touches – an approach that helps to prevent a "painting by numbers" effect. An exciting spontaneity arises from not quite knowing what will happen next.

Tackling figures

This slightly warm, neutral ground responds well to white at one end of the tonal scale and to black at the other. Very few swift brushstrokes are needed to convey the shape and movement of human figures – in this case, flower-sellers going about their business. The canvas board on which this was painted creates an interesting texture. It also tends to take up a lot of paint, so the color has been applied quite thickly.

ALLA PRIMA PAINTING

THE MOST SUCCESSFUL ALLA PRIMA work – also called "direct" painting – relies on a certain bravura in the brushwork and an instinct for the right tone or color. These qualities produce the sparkle

that is created by painting directly from the subject – whether working from real life or from a photograph – and by completing the work in a single session. In this alla prima painting, with its effective use of deep, dark browns and ochres, a contemporary scene at a busy café in a train station takes on an atmospheric 19th-century look. The warmth of the ochres is well complemented by the cool, pale blues.

Effective preparation
While alla prima is a very direct method, preparatory studies made to guide the choice of colors and the composition can actually free up the work and make it look more spontaneous.

1 ▶ To add a lively surface texture, work on a primed cotton canvas. The fact that acrylic dries so rapidly not only helps with overpainting, but also makes canvases easier to carry around – very useful when working outdoors. With a No.10 filbert bristle, paint in the overall background color broadly, using thick paint. Mix mainly Titanium White and Yellow Ochre with a little Azo Yellow, Cadmium Orange, and Burnt Umber for extra warmth. Think ahead – the slightly darker wedge near the center will form the basis of the floor of the café.

2 ▲ Now, adopting a dry-brush technique with the No.7 bristle, rapidly sketch all the main shapes in the dark colors that create the rich, inviting tones of this café interior. Use mixes of Phthalo Blue and Ivory Black, Burnt Umber and Ivory Black, and Burnt Umber and Cadmium Orange. Your brush should be very dry; use a minimum of paint and keep the pressure of the brush on the canvas light – your work at this stage should be ephemeral and open to easy alteration.

3 ◀ Turning your attention to the foreground, load the large bristle brush with a lot of Titanium White, warmed slightly by a dash of Cadmium Orange and Azo Yellow. Always mix your colors on the palette, but build up paint on the canvas progressively until you achieve the right tone. Start to block in some of the other main areas of color in a rough, free way. Although you are working very quickly, be sure to remember to wash your brushes continually and thoroughly, so that they never become clogged with dried, water-resistant paint.

5 ◀ Move on to the figures on the other side of the painting, using quite dry paint to cover areas quickly. Define shapes such as the chairs with an outline of Burnt Umber. Notice how a rapid up-and-down brushstroke on the man's trousers provides coverage and an interesting surface texture. Effective brushwork is very important – for alla prima painting, you will have to rely much more on the "autonomy" of the single brushstroke.

4 ▲ Having blocked in most of the main areas, begin to add detail to the right-hand side of the composition, as the girl and the table form the real core of the painting. When painting details, such as the girl's shoes, load a small, soft brush with thick paint and work very quickly and decisively to create a drawn effect.

6 ▶ Now that you have basically completed the central band of the composition, start work on the architectural surround. Apply the broad areas of color with a blend of Turquoise, Yellow Ochre, and Burnt Umber, tracing the light, fine lines with Burnt Umber. Once this is complete, step back and reassess the painting, adding further detail and minor alterations to every part until you are completely satisfied with it as a whole.

The whole flat area of the filbert has been used for overall coverage, and the olive and brown lines of the architecture have been made with the edge of the brush. Make sure that you use every angle of your brush – in the final picture, you can see how all kinds of different types of brushwork have been used to convey the scene effectively.

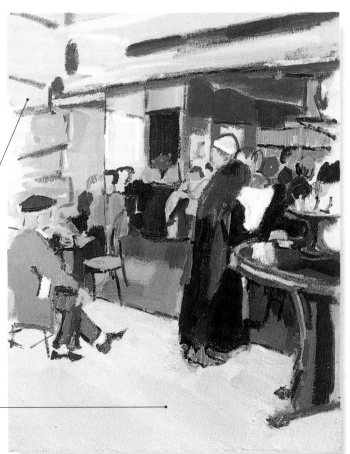

Assessing the scene

The composition falls into three main blocks – the interior of the café, the architectural surround, and the foreground. When using this fast painting approach – especially if you are working outside in a busy location – it is important to assess the scene quickly. Once you come to understand the way you work and the materials, this mental editing process will become automatic.

The pale color of the station platform has been intensified in places at the last minute. This anchors it properly within real space. When working alla prima, make sure that you allow yourself the vital readjustments needed to give the work unity.

Materials

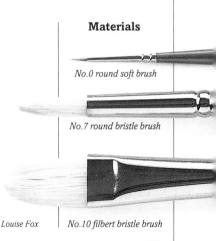

No.0 round soft brush

No.7 round bristle brush

Louise Fox | *No.10 filbert bristle brush*

COMBINING TECHNIQUES

THE GREAT VERSATILITY of acrylic paints becomes obvious when several very different techniques are brought together to function in a rich and often complex manner within the same painting. Here, washes of transparent color are combined with thicker overlaid opaque color and thin, semi-opaque scumbling, as well as various resist techniques.

A painting may go through many permutations before you are happy with the final image. In this case, although the models were outdoors, the plan was to turn the scene into an indoor one, with light flooding in from the left and a window looking out. As the work progressed, reality prevailed and, with some reworking, the scene was reinstated outdoors.

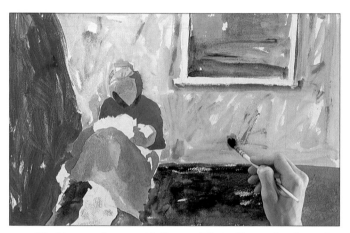

1 ▲ Working wet-in-wet with Raw and Burnt Sienna, lay down the initial wash for the faces, adding Phthalo Blue and Cerulean Blue to create subtle color on parts of the skirt. A Phthalo Blue wash provides the rich color of the sweater. Dry-brushing with French Ultramarine creates textures in the deep shadow on the left. Sketch in the window with neutral washes. Loosely dry-brush opaque Raw Sienna over orange oil pastel, used to add texture, on the back wall.

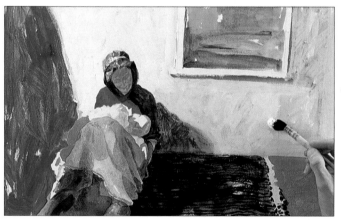

3 ▲ Add more of the finer details – for example, the pattern and knots on the rug and the decorative edging on the woman's skirt. An extremely faint, transparent wash of Cerulean Blue adds form to the baby's pullover. Vigorously dry-brush opaque white onto the rear wall so that it does not quite obliterate the Raw Sienna, which still comes through in areas and has a significant impact on the finished work.

2 ▶ Create shadows on the sweater and around the face with a Phthalo Blue-based purple. A Deep Brilliant Red wash warms up the dark green of the rug. Wash in the shadows between the feet with French Ultramarine and Cerulean Blue over rust oil pastel. It is a good idea at this stage to sketch in facial details with a fine, round soft brush – use well-diluted Burnt Sienna for a very delicate feel. Add faint shadows of Burnt Sienna to the skirt. As the work progresses, it is important to achieve a balance between the broad and the detailed areas; do not leave all the detail until the end.

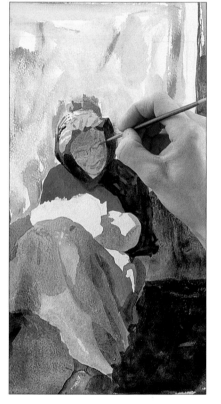

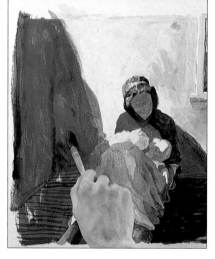

4 ◀ A wash of Raw and Burnt Sienna lessens the stark effect of the white rear wall, adding subtle shadows. Stripes of Deep Brilliant Red have the effect of throwing the rug into shadow. Using a round, medium-sized brush, scumble a thin, semi-opaque lilac over the shadows on the wall. This subdues the blue, creating some textural interest, resonant tones, and depth.

OVERPAINTING

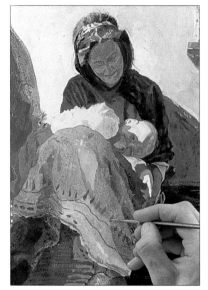

The internal window, looking out

The window started as an internal window, looking out onto a scene of fields *(left)*. The artist was unhappy with the view through the window, reworking it several times. As the painting progressed, the window started to have the feel of a painting on the wall, but as soon as it was re-worked in dark shades, turning it into an external window *(right)*, the picture was transformed. The new version of the window ties in better with the blue of the shadows and the woman's clothes. It is a rather atmospheric use of thin transparent darks scumbled over opaque lights, that suggests the shadowy flower pots at the window.

The external window, looking into the cottage

5 ◀ Crosshatching is a useful way of blending facial tones; use a mixture of Raw and Burnt Sienna and a fine brush to add detail to the baby's face. Keep adding Deep Brilliant Red, as well as Titanium White and blues, to this mix to capture the shadows on the face. Purple shadows on the skirt define the baby's hand. Add pattern to the skirt with sensitive lines and dabs of opaque color – these enhance the loose, relaxed effect of the skirt material.

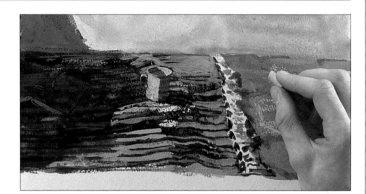

6 ▲ Concentrate on the floor area – at this stage the addition of a coffee mug and the suggestion of an opened book adds foreground interest. A pale green wash gives the effect of sunlight falling across the rug, while white, orange, and rust oil pastels added to the floor area suggest stonework.

The window has been created with a rich and quite complex variety of techniques.

The bold contrasts between light and shade and between very different colors give a strong formal structure and clarity to this otherwise relaxed painting. But even heavily-worked areas such as this still retain a looseness in the brushwork and a vivacity that keeps the painting fresh. This informality is perfectly in keeping with the intimacy of the scene.

Julian Bray

Materials

White oil pastel

Orange oil pastel

Rust oil pastel

No.2 round soft synthetic brush

No.4 round squirrel brush

No.6 squirrel brush

Against the cottage wall

The strong colors of the first stages of the composition have been subtly transformed into an appealing study of a mother and baby. The sun pouring in from the left casts deep shadows, *ranging from cool lilacs to warmer tones around the figures. The wall, having undergone several metamorphoses, now successfully recreates the texture of the whitewashed, rendered original.*

GALLERY OF TECHNIQUES

As you get used to working with acrylics, your technical knowledge and repertoire will increase, and you will find that you are using the medium in many new ways. This process of opening out will enable you to see that there are all kinds of ways of arriving at solutions to painting problems. Acrylic paint is extremely flexible, and you can adapt it to hugely varied methods of painting. The following artists incorporate a wide range of working methods and ways of combining different techniques. William Henderson's work shows clever effects with blending; spraying and using stencils feature in Michael Andrews's painting; while Chuck Close employs photographic projection to give his subjects a remarkably powerful presence.

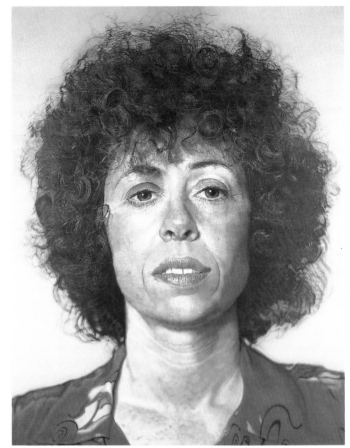

Chuck Close, *Linda, 1975–76* *108 x 84 in (274 x 213 cm)*
Close works by projecting photographs onto the canvas. This may look very much like a photograph, but its huge size offers a different experience; it is clear that we are looking at the physicality of painted washes. Combining these "close-up" and "far off" aspects produces strong, bold images.

William Henderson,
Little Operas (Theme No. 2) *55 x 50 in (140 x 127 cm)*
Through skillful blending, the artist has created a busy quality that gives us the sense of looking down on an insect colony. Just when one area seems to be the key to the work, our attention is drawn to another part.

Henderson has achieved his unusual effects by juxtaposing areas of blended paint. Through this technique, dimensional elements begin to appear, while the ragged edges of the brushstrokes leave the shapes unresolved, with a deliberate "out of focus" quality.

Bernard Cohen,
9 Stops

73 x 73 in (185 x 185 cm)
There is a real depth in this work, created by Cohen's special way of stenciling. A meticulous process of repeated masking out, rubbing down, repriming, and painting produces dazzling, multilayered works. While an area of one color may seem to be above another, it is often physically beneath it – Cohen rubs some areas back almost to the canvas before painting them. He views stenciling as part of the folk art tradition: his components – the stencils – are cut on a table before he assembles and uses them directly on the canvas.

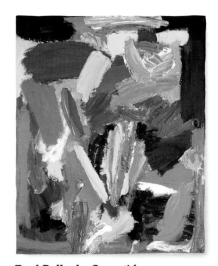

Fred Pollock, *Caryatid*
80 x 66 in (203 x 168 cm)
This painting, executed in vigorous brushstrokes, illustrates the artist's breadth of knowledge: how to use shape and direction, how colors react together, and how to balance a composition.

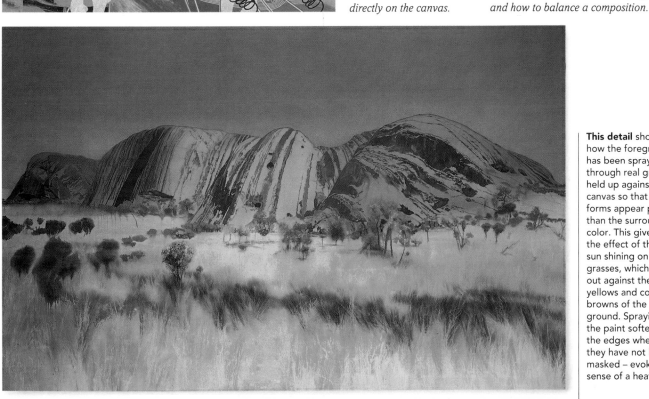

This detail shows how the foreground has been sprayed through real grasses, held up against the canvas so that their forms appear paler than the surrounding color. This gives the effect of the sun shining on the grasses, which stand out against the warm yellows and cooler browns of the ground. Spraying the paint softens the edges where they have not been masked – evoking a sense of a heat haze.

Michael Andrews, *The Cathedral,*
The Southern Faces / Uluru (Ayers Rock),
1987 *96 x 153 in (244 x 389 cm)*
Andrews combines a high degree of technical expertise with a poetic nostalgia. His works are invariably quiet and serene, with a sense of detachment. He never allows the paint to go out of control, restraining it within a linear style in which each form is carefully observed. Here, the combination of spray painting with regular brushwork, and the deep blue sky, convey an impression of blistering heat.

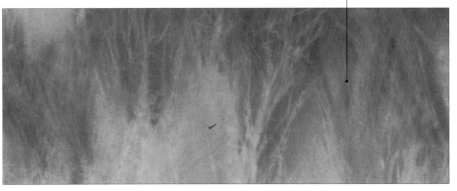

EXPERIMENTING WITH ACRYLICS

OIL PAINT has such a weight of cultural history behind it that artists new to the medium can find it intimidating. Acrylics are relatively young, so artists feel that they can experiment more freely. The fast drying times and ease of overpainting also help to build confidence – if one area of your painting is not working the first time around, you can try something else out practically right away. Also, because the dried acrylic paint film retains its plastic flexibility and stability, even in very thick applications, acrylics can be used thickly with far less fear of creating a potentially fragile work than with oils. Acrylic can be dripped, poured, sprayed, scraped, extruded – even knotted and woven. Other techniques are just waiting to be discovered.

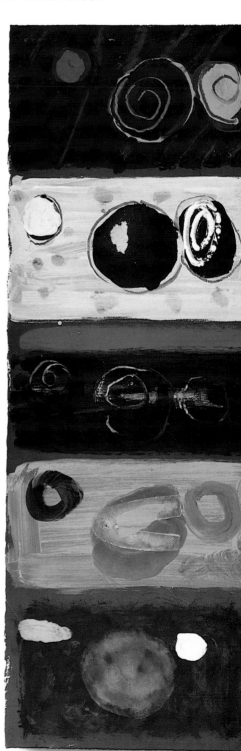

Creative sampler
These different techniques show the versatility of acrylics. Sgraffito was used here, and stripes were wiped out of the wet black paint with a damp paper tissue.

Removing paint
In this sample, the white on the right-hand black shape was applied straight out of the tube. Dabbing with a damp sponge has created dots over the main white area.

Layering paint
This was created by washing over layers of different colors with Ultramarine. Shapes were then scraped back to the brown and yellow paint underneath.

Form and texture
Forms were printed by pressing painted cardboard shapes onto a yellow ground. Sandpaper rubbed into wet yellow paint on the right produced an unusual texture.

Rough ground
Dark gray paint, applied very roughly with a toothbrush, provides the ground on which shapes were printed with thickly painted cardboard.

Sgraffito technique
Sgraffito – from the Italian for "scratching" – describes scratching through fairly thick wet or dry paint to reveal the original surface or another color underneath. Any sharp implement can be used. Here, a thumbnail scratches back to the white paper through a layer of Burnt Umber.

Inventive scraping
There are many scraping techniques (see p.21). Scrape swathes of single or combined colors across your painting surface. Scrape thin acrylic – or a glaze of gel medium and color – over a painted image. This plastic glue scraper has actually produced a type of sgraffito effect.

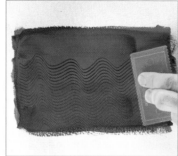

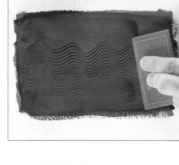

Rich mixtures
Achieve unusual effects by mixing thick color very loosely. A flat bristle brush was used to make these rich, impasted strokes. The outer rectangle – a loose mix of Phthalo Green and Azo Yellow – surrounds Azo Yellow combined with Cadmium Red. Because dried acrylic is so flexible, there is less chance of thick paint breaking up or flaking than with other media.

Making patterns

Develop a personal style by experimenting with any materials you have on hand. Cadmium Yellow has been allowed to dry before painting Phthalo Blue over the top. Lifting the wet blue paint off by dabbing with a dry paper tissue leaves a mottled pattern.

Rubbing through

A very different texture has been created here. Layers of colors were overpainted, allowing each to dry before applying the next. Rubbing with sandpaper has revealed colors underneath the black. Rub harder in some places to uncover deeper layers. The sandpaper lends an unusual "cross-hatched" texture of its own.

Simple scraping

This black and white sgraffito effect – using a thumbnail to scrape through black paint to a white layer beneath – is very simple, but starkly effective.

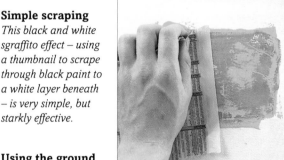

Lifting off

Cadmium Yellow has been applied to grained watercolor paper with a roller and left to dry. A mix of Cadmium Yellow and Cadmium Red has then been rolled over the top, and a scrap of newspaper pressed down lightly over the wet paint and quickly removed. The paint lifts off unevenly, and a varied overall texture emerges.

Using the ground

Layering different, semitransparent colors has produced three-dimensional forms. Good use is made of the gray with which the whole sheet was originally toned.

A working theme

Try experimenting around a theme – these samples were inspired by the shapes of fruit. Here, fingerprints give the red ground an interesting texture.

Wax resist

Here, orange and red washes have fused with each other. Paint has not "taken" where lines of wax resist were applied to the paper, creating a shimmering effect.

Wiping out

The rich yellow circle of paint was applied out of the tube. The gray crescent on the right was wiped out of the wet black paint, back to the gray-toned paper, with a damp tissue.

STENCILING AND PRINTING

Stencils are often used by artists working in acrylic. Shapes cut out of cardboard make ideal stencils, or they can be painted and pressed onto the painting surface to produce a printed image. Keep all your shapes for future use. When used repeatedly, they become attractive objects in themselves; you might incorporate some in a future collage.

1 *Paint a layer of Naphthol Crimson onto a piece of paper. Leave to dry for about 10 minutes. Holding your shape down, paint over its edges with a large brush loaded with Hooker's Green.*

2 *Now lift your stencil shape off the surface carefully but swiftly. Choosing the complementary colors red and green has made this very simple stencil exercise particularly effective.*

A selection of shapes used for stenciling and printing

EXPLORING NEW IDEAS

ONE OF THE MOST important aspects of painting in acrylics is that you should enjoy experimenting with the possibilities of the medium. If you tend to work in a close or tight style, try loosening up – even if you seem to be making a mess with your paints. It is only by trying out new things that you will add to your technical repertoire. This lively and exuberant composition is the result of a series of experiments with an image which was taken first from life.

The many methods explored on these pages include cutting up and reforming the image, stenciling, printing, and splash techniques. The image has gone through a number of permutations, but the finished result has a freshness and vivacity that reflects the pleasure that has gone into making it.

Working from life
A simplified life drawing provides the basis for the final abstract image.

1 ◀ Copy the main shapes of the simplified sketch onto cardboard. Cut these out, number them for reference and lay them on a sheet of smooth paper.

2 ▲ Lay a wash of Ultramarine and Phthalo Blue around most of the cut-out shapes. This overall hue lends the work an air of gentle calm.

3 ▲ Carefully remove the pieces of cardboard to reveal their shapes, left as exposed white paper.

4 ▲ Paint one side of the V shape with a mix of Yellow Ochre and Raw Sienna. Leave to dry and add another coat – the first coat acts as a primer.

5 ▲ While the second coat of paint is still wet, place the shape – painted side down – onto the painting surface, in its original position.

6 ▲ Press down onto the shape with an even, sustained pressure. Use anything that is available – a rolling pin, your hands, or even your feet.

7 ▲ Remove the shape quickly but carefully. The printed impression shows the original brushstrokes made when the shape was painted.

8 ◀ Repeat this with other cut-out shapes, one at a time. To achieve varied effects, apply differing amounts of pressure, or overprint shapes to intensify the color. Note that Naphthol Crimson, with a touch of Cadmium Red, was painted between shapes in the top left to emphasize the face area.

9 ▶ With a large brush, paint black crosses freely across the bottom to bring this area forward. These touches add interest and depth – the work no longer appears to be all on the same plane.

Materials

No.4 round soft synthetic brush

No.10 round soft synthetic brush

Soft Japanese brush

³/₄ in flat soft wash brush

10 ◀ Replace most of the cardboard shapes, so that the printed parts are covered. Using the No.10 and 4 brushes, flick a dark mix of the basic blue wash across the central blue areas. This adds a raw, exciting energy, as well as a surface texture that gives the areas underneath greater depth.

Burnt Umber painted on top of this yellow strip makes it recede (bright colors such as yellow tend to come forward). This strip represents the original woman's far arm. Adding brown makes it, quite rightly, appear farther away than the other yellow strip – the near arm. At first, too much brown was added, so the excess was quickly wiped off before the paint dried.

11 ▲ Take a break to reassess your progress, perhaps looking back to the original drawings. Add touches that will bring all the elements together. Painting a bold red flourish to indicate the woman's hand complements the green underneath – bringing it forward and breaking it up slightly – and balances the red at the top. Use red sparingly – it can be overpowering.

Making marks

In the finished work, Titanium White stars have been added on the left, straight out of the tube. These provide a kind of opposite echo to the black crosses. Repeating marks across a painting – with a slight variation each time – can provide a satisfying harmony.

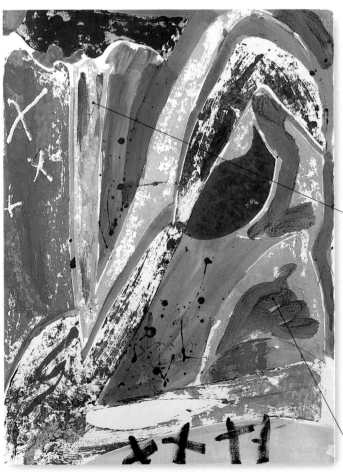

Try using one color in different ways. In this work, blue has been painted, printed, and splattered. The sense of movement and modeling created by painting blue over printed blue suggests a human form. The printed blue stands in front of the painted blue because a lot of white paper shows through the printed parts. White areas are used as a positive element in this work.

Julian Gregg

GALLERY OF EXPERIMENTAL APPROACHES

T HE FACT THAT acrylic paint is a relatively new medium means that artists have felt able to experiment with it more freely than they might with traditional painting media. Morris Louis (*see* p.8) developed a staining technique, and since then other artists have explored methods that rely on the plastic qualities of acrylics. These effects simply could not be achieved with conventional media. Historically, we are still at an early stage in the development of acrylics, and further innovative techniques will no doubt evolve as our knowledge progresses.

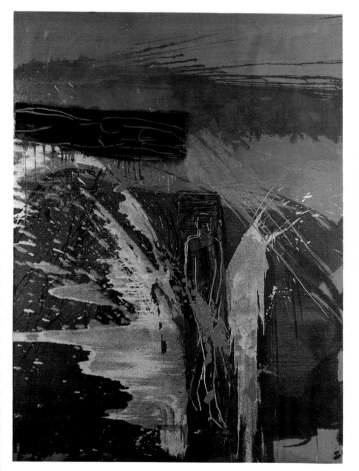

Robert Natkin, *Winchester,* **1992** *73 x 34 in (185 x 86 cm)*
Natkin's shifting layers of opaque and thin color build up a rich but delicate surface. He has developed a way of creating fabric-style textures, and an illusion of collage, through detailed brushwork and by wrapping his brush in cloth. Controlling the brush's pressure gives a range of effects.

Bruce McLean, *Untitled* *102 x 78 in (260 x 198 cm)*
This painting has all the confidence and exuberance of an artist who is happy to pull out all the stops to bring his work to life. Here, he spatters, pours, and throws the paint in thin transparent washes or in thick blobs of color. He paints black over red and scrapes through it to draw his swimming figure. Overall, the work has a refreshing vitality.

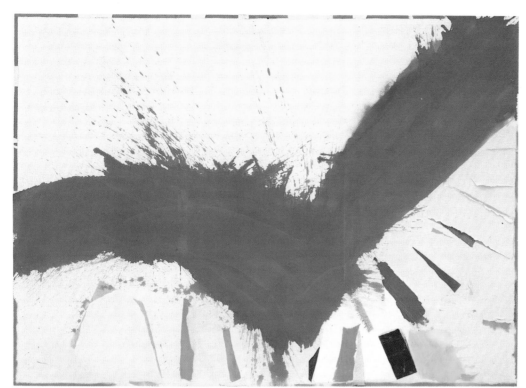

Sandra Blow, RA,
Glad Ocean

102 x 144 in (259 x 366 cm)
Sandra Blow's painting is an ambitious experiment in treading the fine line between spontaneity and control. It hinges around the massive lilac shape, which thunders across the canvas from the left and then changes direction, soaring up to the top right-hand edge. The apparent spontaneity of the purple shape is further counterbalanced by the small, hard-edged shapes. These small forms, so carefully controlled, are like tugs to a tanker. They nestle and nudge the great shape, worrying it into place. Their own position and size add a sense of scale to this powerful work.

Ray Smith, *Self-Portrait* *90 x 66 in (229 x 168 cm)*
This image brings together elements of the artist's life and work, including drawings by his children, an airplane vase by the artist Andrew Lord, and a string of illuminated red light bulbs. The face is based on a tiny brush drawing made by candlelight and then scaled up. The work incorporates the use of splashed, scraped, airbrushed, extruded, and – in the case of the socks – woven paint.

In this detail, the transparent blue has been made up from a touch of blue paint mixed with acrylic gel medium. This blue has been scraped over the splashed paint with a credit card.

The diagonal red has been extruded through a pastry bag, while the vertical red has been poured. The yellow on each side of the black line was airbrushed over white.

PRESENTING YOUR WORK

Cropping compositions
Before framing, experiment with cardboard corners to create the best composition.

THE WAY IN WHICH you choose to present your paintings can have a considerable impact on the final effect. A particularly well-chosen and well-made frame – one that does real justice to the painting – can allow a viewer to focus on the work in a clear and concentrated way. A badly made or ill-chosen frame could detract so completely from the painting that it will be impossible to appreciate it properly. Try to think about presentation as an integral part of your work – not as something that is added as a hasty afterthought.

SOME ARTISTS have a very clear idea of the way in which their work can be enhanced by its frame – for example, choosing to pick up some of the colors in a painting in the frame. Many leave their framing to a framer whose judgment they trust.

Cropping images

Another aspect of presentation is the way in which you choose to crop an image. This is especially relevant if you are working on paper, rather than on canvas or board of a fixed size.

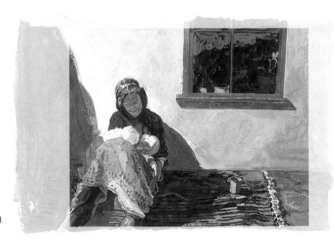

Alternative crops
Focusing on different areas of a painting shows how a variety of totally different works can be created. Here, the slight crop has made the image a little tighter than the original. However, the woman and child are still part of a much larger image, which opens out on each side, making us curious about the world outside the frame.

APPLYING VARNISH

Many artists apply an even, overall coat of varnish over their finished paintings to protect them. Use a flat, long-haired brush – the best kind to ensure a smooth, thin coat of varnish. Most varnishes used for acrylic work contain acrylic resins but dry to a slightly harder film than acrylic paint.

There is some controversy about varnishing acrylic works. With certain varnishes, there is a small "solubility gap" between the paint and the varnish. This means that, if you want to remove the varnish with solvents – if, for example, the varnish has attracted dirt – there is a danger that some of the paint underneath could also be removed. Various new varnishes contain additives that make the varnish harder – which also means that dirt is less likely to stick – but are still removable. Time will tell whether these new types provide the answer.

2in synthetic varnishing brush

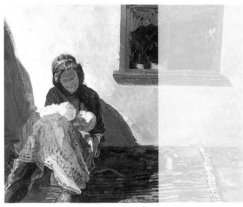

Balance and symmetry
This example closes in to establish a more precise structural balance between the window coming down from the top right-hand edge and the woman coming up from the bottom left. It creates a kind of symmetry that gives the painting a certain poise.

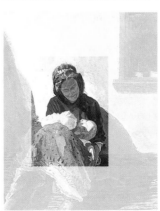

Mother and child
The very close crop of the third alternative focuses all our attention on the human situation of the woman and child. We become particularly aware of the extremely direct look we are getting from the young child as it eyes us from the shadow, and from the protection of its mother's lap.

Changing focus and format

Through well-judged cropping, it is possible to modify a composition quite radically before you frame it, by deciding to block some parts of it out altogether. You may wish either to leave out an area that you feel is not painted particularly well, or to focus more on a small area of your painting by making it a larger part of the whole.

By cropping, you can also change the format from landscape (horizontal) to portrait (vertical), try out alternative crops with a couple of cardboard corners.

Works on paper

Typically, a painting on paper would be framed behind a window mat and glass, backed with hardboard.

The cream mat brings the painting forward naturally because it picks up the color of the brightest highlight in the whole object – the sunlit areas of the dome. Against the cream, we are also able to focus on the depth and color of the dark tones in the image.

The dark frame has a classic simplicity that is in keeping with the relatively traditional style and subject matter of the painting.

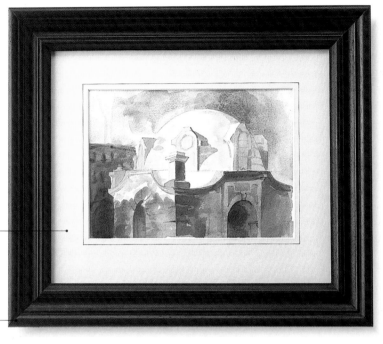

Dark frame, light mount

The presentation of this architectural study works very well because it achieves a successful balance with the painting itself. The dark frame holds the whole work together, while the cream mat allows the image to come forward.

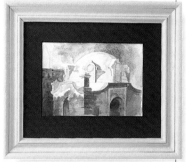

Light frame, dark mount

This is less successful because the contrast between the light pine frame and the mount seems more extreme. This competes with bold contrasts in the painting, making the image appear to retreat.

Mounting your paintings

When framing a painting on paper, ensure that the mat is made from acid-free cardboard. You will often find that neutral mount colors such as the ivory, pale creams, or pale grays commonly used will bring out the colors in your painting. If you are framing a canvas, attach a backing board to prevent the accumulation of dirt and damage from atmospheric changes.

Yellow frame

When framing, consider the style of your work. This kind of image benefits from a modern-looking frame, perhaps in a bright color. Here, however, the bright yellow tone is a little sickly, and competes with the rope in the painting.

White frame

This frame – like the other two, painted wood – makes the deep tones in the image too dark, so that you cannot read the painting's true colors. The intense white in the image makes the frame look slightly dirty and mismatched.

Mixed-color frame

The predominant gray tone of the frame also includes touches of colors picked up from the painting itself. It suits the work because it has a modern feel, and its mid-tone provides a balance between darks and lights in the image.

GLOSSARY

ACID-FREE PAPER Paper with a neutral pH that will not darken excessively with age.

ACRYLIC Synthetic resin that is used in an emulsion as the binding medium for artists' acrylic colors.

ADJACENT COLORS Those colors literally closest to each other on the color wheel; also used to describe colors that lie next to each other in a painting.

AERIAL PERSPECTIVE The effect of atmospheric conditions on our perception of the tone and color of distant objects. As objects recede toward the horizon, they appear lighter in tone and more blue.

ALLA PRIMA Literally means "at first." A direct form of painting made in one session or while colors remain wet. (As opposed to "indirect" painting, in which the painting is built up in layers.) Employed by artists when they want to paint spontaneously.

BINDER In a paint, this is the substance that holds the pigment particles together and acts as an adhesive to the support. In the case of acrylic paints, the binder is an acrylic polymer emulsion.

BLENDING A soft, gradual transition from one color or tone to another.

CHARCOAL One of the oldest drawing materials, made by charring willow, vine, or other twigs in airtight containers.

COMPLEMENTARY COLORS Two colors of maximum contrast opposite each other on the color wheel. The complementary of a primary color is the color that is produced by combining the two remaining primaries.

DIRECT PAINTING *See* alla prima.

DRY-BRUSH TECHNIQUE A painting method in which paint of a dry or stiff consistency is stroked or rubbed across the canvas, producing a broken color effect.

EMULSION In acrylics, a stable suspension of acrylic resin particles in water.

FERRULE The metal part of a brush, which surrounds and retains the hairs.

FLAT COLOR An area of matte color of uniform tone and hue.

GLAZE Applying a transparent layer of paint over all, or part, of a painting to modify the effect of the color.

GROUND The surface on which color is applied. This is usually the coating rather than the support. A colored ground is useful for paintings where the ground provides the halftones and the unifying element for the different colors. A colored ground can also be applied as a translucent stain over a white priming, or as a primer that has been colored.

HALFTONES Transitional tones between the highlights and the darks.

HATCHING Making tonal gradations by shading with long, thin brushstrokes. Often used in underpainting.

HIGH-KEY COLOR Brilliant and saturated color. High-key paintings are usually painted on white or near-white grounds.

HIGHLIGHT The lightest tone in a drawing or painting.

HP OR HOT-PRESSED PAPER Paper with a very smooth surface.

HUE Describes the actual color of an object or substance. Its hue may be red, yellow, blue, green, and so on.

IMPASTO A thick layer of paint, often applied with a painting knife or a bristle brush, which is heaped up in ridges to create a heavily textured surface and a look of fresh immediacy.

LAY IN The initial painting stage over a preliminary drawing where the colors are applied as broad areas of flat color. This technique is also known as blocking in.

LIFTING OUT Modifying color and creating highlights by taking color off the paper using a brush or sponge.

LIGHTFASTNESS The permanence or durability of a color.

LOW-KEY COLOR Subdued, unsaturated color that tends toward brown and gray.

MASKING FLUID A solution of latex in ammonia used for masking out particular areas in a painting. It is available in white or pale yellow.

MASKING OUT The technique of using masking fluid to protect areas of the paper while adding washes. The solution is allowed to dry, paint is applied over it, and once that has dried, the masking fluid is gently peeled off.

Alla prima

Texture paste

Gel medium for impasto

Working wet-in-wet

Glazing

MASKING TAPE Pressure-sensitive tape used to protect areas from paint.

MEDIUM The binding material in paint in which the pigment is suspended. Also used for an acrylic medium which modifies the consistency of acrylic paint for techniques such as glazing or impasto.

MONOCHROMATIC Drawn or painted in shades of one color.

NOT OR COLD-PRESSED PAPER Paper with a fine grain or semirough surface.

OPAQUE PAINTING Paintings that use predominantly opaque paints and the techniques associated with them.

OPTICAL MIX When a color is arrived at by the visual effect of overlaying or abutting distinct colors, rather than by physically mixing them on a palette.

PERSPECTIVE The method of representing a three-dimensional object on a two-dimensional surface.

PHTHALOCYANINE Modern organic transparent blue and green (chlorinated copper phthalocyanine) pigments of high tinting strengths and excellent lightfastness.

PHYSICAL MIX When a color is created by pre-mixing two or more colors together on the palette before application to the support. Wet-in-wet and wet-on-dry techniques refer to mixing paints on the support itself.

PIGMENT A solid colored material in the form of discrete particles. Pigment forms the basic component of all types of paint.

POLYMER A chainlike molecule of which the individual links or units are known as monomers. Acrylic polymers form the basic binding medium for acrylic paint.

PRIMARY COLORS The three colors of red, blue, and yellow in painting that cannot be produced by mixing any other colors.

PRIMING This refers to the preliminary coating that is laid onto the support prior to painting. Priming provides the surface with the right key, absorbency, and color before painting.

RESIST TECHNIQUES A method of preventing paint from coming into contact with either the support or with another layer of paint by interposing a protective coating such as masking fluid. Used either to preserve highlights or to retain a particular color.

RETARDER Added to acrylic paint to delay the drying process. If over-used, the quality of the paint can be impaired.

SATURATION The degree of intensity of a color. Colors can be saturated, i.e., vivid and of intense hue, or unsaturated, i.e., dull, tending toward gray.

SCUMBLING Semi-opaque or thin opaque colors loosely brushed over an under-painted area so that patches of the color beneath show through.

SECONDARY COLORS The colors arrived at by mixing two primaries, i.e. mixing blue and yellow makes green, mixing red and yellow makes orange, and mixing red and blue makes violet. However, if different proportions of each primary color are combined, a range of tones of the secondary color can be produced.

SGRAFFITO A technique, usually involving a scalpel or a sharp knife, in which paint is scraped off the painted surface so that the color of the surface, or a dry color painted previously, is visible.

SPONGING OUT The technique of soaking up paint with a sponge or paper towel so that areas of pigment are lightened or removed from the paper. Can be used to rectify mistakes or to create particular effects.

STIPPLING Applying tiny dots of color with the tip of the brush.

STRETCHER The wooden frame on which a canvas is stretched. Always staple canvas over a frame in a specific order: top center, bottom center, right center, left center, top edge to right, bottom edge to left, right edge to bottom, left edge to top, top edge to left, bottom edge to right, right edge to top, left edge to bottom.

SUPPORT The material on which a painting is made. Almost any surface can be used, but artists tend to use paper, a wooden panel, or a canvas to work on.

TOE The tip of a brush.

TONE The degree of darkness or lightness of a color.

TONED GROUND Also called a colored ground. An opaque layer of colored paint of uniform tone applied over the priming before starting the painting. Alternatively, color can be added to the primer.

TRANSPARENT PAINTING A technique that relies on the transparency of the paint.

UNDERPAINTING Preliminary painting, over which other colors are applied.

WASH A thin, transparent layer of paint.

WET-IN-WET Working with wet paint into wet paint on the surface of the support.

WET-ON-DRY Applying a layer of wet paint onto a dry surface.

Pigment *Laying in a wash* *Resist techniques*

A NOTE ON TOXICITY

- When spraying acrylic color with an airbrush or spray gun, you should always wear goggles and a respirator to prevent inhalation of acrylic or pigment as this can be dangerous.

- Generally, the pigments used in acrylic colors do not pose the same problems of toxicity as some used in oil painting. Cadmium Red and Yellow are slightly toxic; handle with care.

INDEX

ACKNOWLEDGMENTS

Author's acknowledgments

Ray Smith would like to thank Alun Foster at Winsor and Newton, for his expert advice, and Jane Gifford for once more coming up with sparkling images. Thank you to all the artists who allowed their work to enrich the book and to The Royal Academy for valuable assistance. Special thanks to everyone at Dorling Kindersley associated with the series, especially to Ann Kay and Lynne Nazareth for their thoughtful, meticulous work on the text, to Brian Rust for his clear, expertly balanced designs, to Stefan Morris and Dawn Terrey for their design assistance, and to Margaret Chang for her help with picture research.

Picture Credits

Every effort has been made to trace the copyright holders and we apologize in advance for any unintentional omissions. We would be pleased to insert the appropriate acknowledgments in any subsequent edition of this publication.

Key: *t*=top, *b*=bottom, *c*=center, *l*=left, *r*=right; RAAL= Royal Academy of Arts Library, London VAL = Visual Arts Library, London, all rights reserved. *Endpapers:* Jane Gifford; *p2:* Julian Bray; *p3:* Julian Bray; *p4:* Jane Gifford; *p5: tr* Ray Smith; *br* Louise Fox; *cl* Ian

McCaughrean; *p6: tl* Jane Gifford; *cr* Jane Gifford; *bl* Gabriella Baldwin-Purry; *p7: tl* Jane Gifford; *cr* Jane Gifford; *bl* Julian Gregg; *p8: tr* Morris Louis, The Phillips Collection, Washington, DC, © Marcella Louis Brenner; *br* David Hockney, The Tate Gallery, London, © David Hockney 1965; *p9: tl* Andy Warhol, Museum Ludwig, Cologne, © 1993 The Andy Warhol Foundation for the Visual Arts, Inc.; *tr* Bridget Riley, Private Collection /Bridgeman Art Library, © 1993 Bridget Riley, Courtesy Karsten Schubert Ltd., London; *b* Paula Rego, The Tate Gallery, London, © Paula Rego; *p12: cl* Jane Gifford; *br* Ray Smith; *p13:* all Jane Gifford except *c* Ray Smith; *p14:* all Julian Bray; *p15: tl* and *tr* Sue Sharples; *bl* and *br* Julian Bray; *p16/17: c* John Hoyland ARA, RAAL; *p16: bl* Gregory Gordon; *p17: r* and *b* Leonard Rosoman RA, RAAL; *p23: c* Ian McCaughrean; *b* Julian Bray; *pp 26/27: c* Louise Fox; *p26: b* Jacobo Borges, Private Collection, Caracas/Courtesy of CDS Gallery, N.Y./VAL; *p27: tr* Albina Kosiec Felski, National Museum of American Art, Smithsonian Institute/Bridgeman Art Library; *cl* Ronald Davis, Private Collection/VAL; *br* Jane Gifford; *p28: tl* Jane Gifford; *br* Julian Bray; *p29: tr* and *c* Jane Gifford; *b* Ray Smith; *p30: c* and *b* Jane Gifford; *p31:* all Jane Gifford; *pp32/33:* all Jane Gifford; *p34:* all Jane Gifford; *p35: t* and *c* Ray Smith; *b* Jane Gifford; *p36: tr* Jo Kelly; *cl* Gillean Whitaker, RAAL; *p36/37: b* Patrick Caulfield, The Saatchi Collection, London, © Waddington Galleries Ltd., London; *p37: tl* Mike Gorman, Private Collection/VAL; *tr* Jennifer

Durrant, RAAL; *p38: tl* Jane Gifford; *c* and *b* Ian McCaughrean; *p39:* all Jane Gifford; *p40/41:* Derek Worrall; *pp42/43:* all Julian Bray; *pp 44/45:* all Julian Bray; *p46: tr* Christopher Lenthall; *bl* Gabriella Baldwin-Purry; *br* Jane Gifford; *p47: tl* Albert Irvin; *tr* David Evans; *br* John McLean, Art For Sale/Francis Graham Dixon Gallery; *p48:* all Ian McCaughrean; *p49: tr* Ian McCaughrean; *c* and *b* Jane Gifford; *p50/51:* all Jane Gifford; *p52: tl* and *tr* Sue Sharples; *p53:* Ian McCaughrean; *pp54/55:* Louise Fox; *pp56/57:* Louise Fox; *pp58/59:* Julian Bray; *p60: tr* Chuck Close, Akron Art Museum, Akron, Ohio/Courtesy Pace Gallery /VAL; *b* William Henderson, RAAL; *p61: tl* Bernard Cohen, RAAL; *tr* Fred Pollock, RAAL; *c* and *b* Michael Andrews, Anthony d'Offay Gallery, London; *pp62/63:* Julian Gregg; *p62: cl* Julian Gregg; *cr* Ian McCaughrean; *bl* Ray Smith; *p63: tl* and *c* Ian McCaughrean; *tr* and *b* Julian Gregg *pp64/65:* Julian Gregg; *p66: r* Robert Natkin, Gimpel Fils Gallery; *bl* Bruce McLean, Anthony d'Offay Gallery/VAL; *p67: t* Sandra Blow RA; *b* Ray Smith; *p68:* Julian Bray; *p69: t* Julian Bray; *b* Jane Gifford; *p70: l* Louise Fox; *r* Jane Gifford *p71: c* Julian Bray.

Dorling Kindersley would like to thank:

L. Cornelissen & Son, and Winsor & Newton, for kindly supplying the artists' materials used in this book.
Additional photography:

The Dorling Kindersley Studio and Karl Adamson.